IMAGES
of America

UPPER
SKYKOMISH VALLEY

The Skykomish Historical Society is pleased to present *Upper Skykomish Valley* as part of the Centennial Celebration, 1909–2009.

ON THE COVER: Even if the town does appear much the same, in this era of global climate change, one cannot count on Skykomish looking the way it did here in the winter during the early 1950s with Ed Knutson's spiffy new Pontiac crossing the bridge. The winter of 2007–2008, however, did produce record snowfall, and for the first time since the 1950s, it had to be hauled away on railcars. (Courtesy of Skykomish Historical Society.)

IMAGES
of America

UPPER
SKYKOMISH VALLEY

Warren Carlson and
the Skykomish Historical Society

ARCADIA
PUBLISHING

Published by Arcadia Publishing
Charleston, South Carolina

Printed in the United States of America

Library of Congress Control Number: 2007943604

For all general information contact Arcadia Publishing at:
Telephone 843-853-2070
Fax 843-853-0044
E-mail sales@arcadiapublishing.com
For customer service and orders:
Toll-Free 1-888-313-2665

Visit us on the Internet at www.arcadiapublishing.com

*With greatest respect, this book is dedicated
to the late Bob Norton and to Bob Kelly and Michael Moore.*

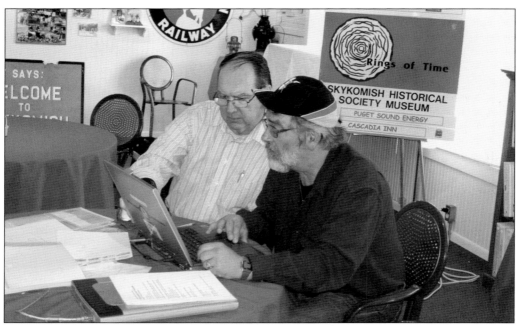

Pictured here, Skykomish Historical Society collection manager Bob Kelly (left) and the author, Warren Carlson, agonize over a photograph. The idea that the amazing history of this valley could be reduced to 200 photographs is already a fool's errand. (Courtesy of Pat Gallagher-Carlson.)

CONTENTS

ACKNOWLEDGMENTS

"Acknowledge" seems a woefully inadequate word to identify and thank so many for the support and guidance this project has received. When Bob Norton's will left the results of his years of dedication and scholarship to Sky Historical Society (SHS), it more than doubled the size of our collection. A majority of the photographs from our collection that appear in this book came from Bob Norton. As a close friend of Bob Norton's, and now as our collection manager, Bob Kelly knows about, and where to locate, every item we have. Bob Kelly's knowledge, guidance, and unflagging and cheerful support kept the work on track and as accurate as possible. Michael Moore's untiring devotion to scanning and labeling every two-dimensional item we possess and placing the information onto disks and subsequently onto a hard drive made our collection searchable.

Rose Marie Koch Williams, Louise Lindgren, and David Cameron cheerfully offered particularly valuable information on a broad range of topics and photographs, and read parts of the manuscript for accuracy and more. Doyle McIntosh provided unique information. Bob Kelly read every word, including those he helped write. David Kennedy read proofs, and Judy Kennedy tracked down census data.

Carolyn Marr at the Museum of History and Industry (MOHAI), Jeff Jewell at the Whatcom County Museum, the staff at the University of Washington Special Collections, Elaine Miller at the Washington State Historical Society Research Center, Ted Jackson at Georgetown University, and Daryl Jacobson all helped provide needed photographs.

Helen Priestley Brumbach, Margaret "Smitty" Smith, Doyle McIntosh, and Bob Kelly generously shared their personal memories and photographs from their personal collections. Darrin Nelson made the terrific map. HistoryLink.org filled in blanks.

No pictorial history of Skykomish Valley could happen without the lifetime achievement of photographer Lee Pickett, whether he was spelling his last name with one "T" or two. Most of what is known about how things in this valley looked in days of yore comes from his images, now a special collection at the University of Washington. SHS owes a particular debt to Darlene Holdridge Waite for sharing her scholarship and to Mike Shawver, who just keeps bringing us treasures. And this book owes much to all the members of the historical society, past and present, who have shared their photographs and stories. Thanks also to Julie Albright and cheerful Sarah Higginbotham at Arcadia Publishing.

And, of course, thanks to the ever graceful Pat (Henry) Gallagher-Carlson, who moved her office to the guest room as the piles of materials mounted and who helped and counseled and read proof and dug up material and maintained her charm and perspective throughout.

All photographs are from the Skykomish Historical Society collection unless otherwise noted. The following image sources will be identified as follows: MOHAI is Museum of History and Industry; UWLSC is University of Washington Libraries, Special Collections.

INTRODUCTION

This is not "the" history of Skykomish Valley or even, really, "a" history of it. It is some history and some speculation about how it developed; it is largely a story about transportation and how nearly all the significant changes in the valley were influenced by it.

When James Jerome Hill, the man ultimately known as "The Empire Builder," was wheeling and dealing in St. Paul, Minnesota, in the 1880s, he had no idea Skykomish Valley existed. He recognized there was an enormous opportunity in establishing a railroad to the Pacific Northwest; not only were there vast quantities of standing timber and mineral resources, such a rail line would also traverse thousands of square miles of potential agricultural land as well.

Earlier Great Northern Railway attempts to find a route across the forbidding Cascade Mountains had been unsuccessful until a young locating engineer named John F. Stevens made Hill's dream a reality. Stevens's first accomplishment for Great Northern had been to locate the lowest and most efficient route through the Rocky Mountains at Lost Marias Pass in Montana. He accepted the challenge of the Cascades and, starting in Wenatchee, began looking for a route to Puget Sound.

The pass Stevens found, which would subsequently bear his name, was hardly ideal, but Hill needed a rail line completed to begin creating revenue, so any workable routing was better than none. The original rail line over Stevens Pass required a series of eight switchbacks, sharp curves, steep grades up to four percent, and a crew of 3,000 men working 12 hours a day for two years to complete it. The final spike was driven on January 6, 1893.

John Maloney was 33 years old at the time he met John F. Stevens. The only one of five boys in his family to go west, Maloney labored in mines, prospected in at least four states, operated a copper claim in Utah for eight years, and then went to Alaska, where he floated the Yukon River to the sea in a moose-skin canoe looking for copper. Since it was too late in the year to go back inland, he took passage on a steamer to Seattle. After his job as an axman on a survey crew out of Bellingham ran out, he moved on to the head end of Lake Chelan, where he located a ranch. By the time he met John Stevens, Maloney was an experienced wilderness traveler with an eye for opportunity.

When Stevens chose to locate the Great Northern Railway along the Sorth Fork of the Skykomish River, Maloney recognized his main chance. He staked a claim along a wide, flat stretch of river bottom along the route the rails would take in 1891 and began to clear land. He knew the building of the railroad would require all manner of support systems and positioned himself to provide them. The place he claimed became Skykomish.

During the years James Hill was planning and bringing his railroad from the east, prospectors and surveyors were also coming up the valley from the west. Amos D. Gunn and his wife, Persis, saw their opportunity in providing services to these explorers when they bought a prospector's claim just east of the main fork in the Skykomish River. Almost immediately, the Gunns enlarged their cabin to provide accommodation for the increasing numbers of prospectors who were coming into the area, and when news of a coming railroad and an important strike of galena (lead ore) was discovered 8 miles east of them in 1890, the Gunns and others were well positioned to prosper. The town that grew around them became Index.

In 1900, the town plat of Berlin (changed to Miller River early in World War I) was registered with more than 500 lots, and the avenues were named for the mines operating in the hills above town.

Shortly after the completion of the Great Northern Railway (GN), much of America was reeling from the Panic of 1893, and while this economic downturn created havoc in the East and devastated numerous heretofore thriving businesses elsewhere in the United States, for much of the 1890s in the Upper Skykomish Valley and along the GN tracks, it spelled opportunity. Canny old James Hill was busily flogging the advantages of leaving the depressed Mississippi Valley and relocating to farms and ranches along his rail line. Additionally, the allure of striking it rich, or at least making a real living in the West, meant there was a renewed supply of labor to develop, among other places, Skykomish Valley.

By 1900, east of Index along the tracks, there were settlements at Heybrook, Halford, Baring, Grotto, Berlin (Miller River), Skykomish, Tonga, Nippon, Madison (Scenic), Corea, Martin City, Alvin (Embro), and Wellington (Tye).

Earlier transcontinental railroads had been built in some measure by cheap Chinese labor, and as a result, out of work native-born Americans and other white immigrants brought about the Chinese Exclusion Act of 1881, a federal law prohibiting Chinese from entering the United States to work on railroads. Hill was already negotiating with the Japanese about selling U.S. goods to them and importing tea and silk when his railroad was ready, and the story persists that based on this relationship, he was able to bring cheap labor from Japan. Thus one of the boomtowns that sprang up along the tracks was called Nippon and was where these Japanese laborers lived. Whether this is true or not, it does provide a colorful explanation of the town's name. The 1900 census lists 47 Japanese workers in the Wellington and Martin Creek districts, but it does not mention Nippon.

Whether the impetus for locating a town was the railroad or mining, they all were sawmill towns as well. Between the railroad, the mines, and the boomtowns that sprang up in support of them, there was an early market for lumber and shingles throughout the valley. And once the railroad was operational, new markets came into play, sending lumber east and west.

Until the Great Northern, railroad freight in the northwest largely consisted of goods moving west. Hill knew he could only make money if he could fill his freight cars in both directions. In addition to products from the Orient, he recognized that the Great Northern could transport lumber east on cars that would otherwise travel empty at significantly reduced rates, and he convinced his neighbor and friend Frederick Weyerhaeuser to look to the west with him.

The railroad itself remained labor intensive. The large crews needed to build the initial rail line became large maintenance and snow removal crews. The route over Stevens Pass was hardly ideal, with eight switchbacks required to complete the line and sections of track above 3,000 feet in a serious snow belt. Snaking railcars in eight-car units up and down the switchbacks required significant crews working round the clock. Within only a few years of the Great Northern being "completed," work began on the first Cascade Tunnel to replace the switchbacks.

This tunnel opened in 1900, and while it solved the switchback problem, it created its own concerns as the exhaust from the steam engines resulted in several deaths and numerous close calls. Within a few years, plans were made to "electrify" the tunnel, allowing trains going through to be pulled by electric engines. This was completed in 1909.

The population of Washington in 1900 was 518,000. In 1910, it was 1,142,000, making Washington the fastest growing state in the nation. A significant number of these new citizens found work in Skykomish Valley. The number of people living in the upper valley in the summer of 1910 was perhaps 15 or 20 times what it is today. Although much of the work was seasonal, Index, Baring, Grotto, Berlin (Miller River), Skykomish, Alpine, and Wellington all had sufficient year-round populations to require schools.

In March 1910, the upper valley was suddenly "on the map" all over North America and beyond when the greatest avalanche disaster in U.S. history occurred at Wellington, killing 96 people. Such a tragedy might have derailed the economic viability of a lesser man than James Hill and the organization he commanded. In 1929, when the 7.8-mile tunnel was completed, in his dedicating remarks, GN president Ralph Budd pointed out that GN was the only transcontinental rail company in United States to have paid dividends "every year."

The first automobile in Index arrived in 1911. Willard Fillmore Smith of Berlin spearheaded a Good Roads Club, and King County funding was found for a road as far as Skykomish. In 1912, the Scenic Highway Association was founded with George Startup from Startup, Washington, as president and other officers from Cashmere and Everett. Clearly the idea of a cross-Cascades highway was taking root. By 1913, there were gas stations at Baring, Grotto, Berlin (Miller River), and Sky. Attempts at finding funding for a road over the pass gained random successes until World War I interrupted further progress.

For other enterprises in the valley, however, the war meant only more economic opportunity. At Nippon (later called Alpine), the Nippon Lumber Company operated successfully, mostly producing 12-by-12s for railroad snow sheds. Between 1910 and 1914, the mill's annual output went from 150 railcars to more than 500 and peaked at 600 until after the war.

From the time the GN was completed, tourism efforts followed. A 50-room destination hotel was built at Madison to take advantage of the "healing" hot springs and offer other recreational opportunities such as fishing, berry picking, and hiking. Original photographs show it as the Great Northern Hotel, but it soon became the Scenic Hot Springs Hotel, and in 1906, it was doubled in size. This hotel burned in December 1908, but by June 1909, barely six months later, a chalet-style hotel had replaced it in time for the Alaska-Yukon-Pacific Exposition happening in Seattle.

Throughout the 1910s and 1920s, GN ran special weekend excursion trains making stops along the way for campers, fishermen, berry pickers, and other holiday makers from the Puget Sound area to enjoy the mountains. Although the U.S. Forest Service presence in the early years was small, it did build and maintain campsites at various locations.

The 1920s roared into Skykomish Valley as elsewhere, with optimism and investment happening throughout valley. Accounts vary, but while national Prohibition began in 1920, it did not seem to change how people in the valley lived. Oral accounts of children selling empty bottles back to the bootleggers who operated in the centers of towns indicate enforcement was erratic at best. The Olympia Tavern in Skykomish, for instance, was renamed the Maple Leaf Card Room and Confectionery and operated continuously throughout.

The Northwestern Cement Company broke ground in 1926 for a plant in Grotto, but GN's decision to build the longest tunnel in the western hemisphere from Berne to Scenic was by far the defining initiative of the decade in Skykomish Valley.

Between 1925 and 1928, crews of men worked three eight-hour shifts a day seven days a week to build the tunnel in record time. Along with boring the tunnel came the decision to electrify the line from Wenatchee to Skykomish. In Sky, this meant building the four-story "Substation" where electricity from the Puget Sound Power and Light grid would be converted from alternating current (AC) to direct current (DC) power and the voltage increased to drive the electric engines. This ensured the railroad would be a dominant presence in town for the next three decades.

The tunnel and changing times did, however, spell the end of many little boomtowns along the tracks. The mill at Alpine, for instance, closed, and people moved away. By 1930, the U.S. Forest Service burned the town to prevent squatters from taking up residence there and possibly starting forest fires.

The Great Depression squeezed life in the valley much the same as in the rest of the nation. Numerous mills and mines closed. New Deal government-supported Works Progress Administration (WPA) and Civilian Conservation Corps (CCC) projects represented a significant portion of the economic activity in the 1930s.

The new Skykomish School in 1936 was a WPA project. The school is a King County Landmarked building and remains in use today. A ski lodge at Stevens Pass was built in 1937. When it burned in 1939, the replacement lodge was funded by private ski clubs and was built on the same foundation with CCC labor. The lodge is in use today.

The Bloedel-Donovan mill near Sky closed from 1931 to 1936, and even after it reopened, at one point there is reputed to have been 1.5 million board feet of unsold, sawed lumber "in the yard."

World War II spurred the economy a bit, but thereafter, economic vitality quietly ebbed away. Not a single meaningful new industry was started. Mills were closed or sold and downsized and

then eventually closed. The cement plant at Grotto closed in 1970. The U.S. Forest Service hired trail clearing crews in the summer, but these too became fewer over the years. By 1956, GN had converted all trains to diesel power, and the substation went out of service. Gyppo logging operations worked steeper and steeper ground, trucking the logs to Everett or Lake Washington or elsewhere "down below." In the 1950s, Holdridge and Wren, HM&H, Priest, Monoghans, Clevenger, Domrude, O'Reilly, Carlson and Wahto, and other small logging operations each extracted a few million board feet of timber from the valley per season. By the 1970s, all were either out of the logging business or working elsewhere.

The accomplishments of Skykomish sports teams are the stuff of legend. Early baseball teams consistently dominated the region, as did school teams in several sports. In the early 1940s, the high school basketball team posted victories over Bothell, Stanwood, and other large schools, and in 1954, Sky became (and remains) the smallest school in history to win the state championship. The 1965 team won 24 consecutive games and finished sixth at state in a year when there were fewer than 30 boys in school. Enrollment at the school is now small enough some years that it is difficult for Sky to field a basketball team.

Images of America: *Upper Skykomish Valley* is about 30-something miles of real estate between where the South Fork and North Fork of the Skykomish Rivers meet on the west to the summit of Stevens Pass, named for the engineer who located the route.

One

1890–1900

Nothing explains the explosive growth of the Upper Skykomish Valley beginning about 1890 better than a paraphrase of James Carville's now famous political expression: It's the economy, stupid. For Skykomish Valley, it was economics, plain and simple. The decision to route the Great Northern Railway along the South Fork of the Skykomish River and the discovery of a large deposit of galena (lead ore) above the North Fork triggered an economic frenzy that totally transformed the upper valley within two decades.

The so-called "Gay Nineties" was a period of rapid expansion in the Pacific Northwest. Massive fortunes had been amassed in the East, and railroads were creating economic opportunities in all directions. The Panic of 1893 depressed employment and investment in the East, causing large numbers of people to go west. When Washington gained statehood in 1889, little was known about whole sections of Washington's mountains, but hard times elsewhere meant people were available to pioneer valley enterprises, even if little about their daily lives could be called gay.

People argue whether the Native American "Skaikh" part of the name Skykomish means "inland" or "upriver," as if these distinctions represent a difference. There is agreement that "mish" means people. The Skykomish Indians knew better than to winter in the demanding climate of the valley east of Index. In summers, they camped, hunted and fished, and gathered roots and berries. In winter, they had the good sense to return closer to the flatlands.

The people who followed them sought fortune, and while they could not move heaven and earth, they could and did move large amounts of dirt, cut many trees, and reshaped the landscape in their pursuits.

Empire builder James Jerome Hill recognized the vast potential of American trade with the Orient could be centered in Puget Sound and demanded a direct rail connection between Puget Sound and the East. John F. Stevens, fresh from his success at finding a suitable pass across the Great Divide in Montana, ultimately located a feasible route across the difficult Cascade Mountains, and the rest, as they say, is history.

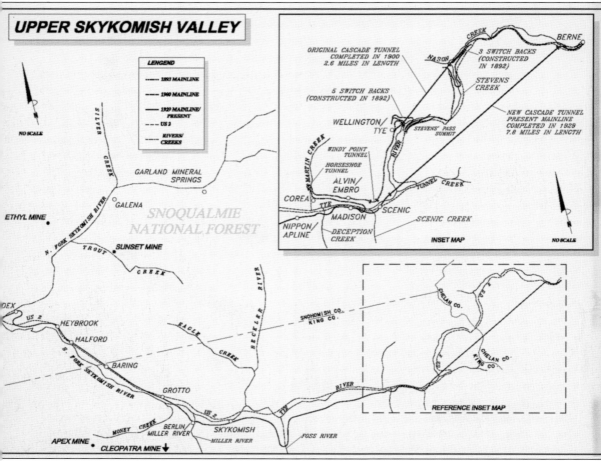

WHERE IT ALL HAPPENED. Most places named in the text are pictured here. (Courtesy of Darrin Nelson, Wenatchee, Washington.)

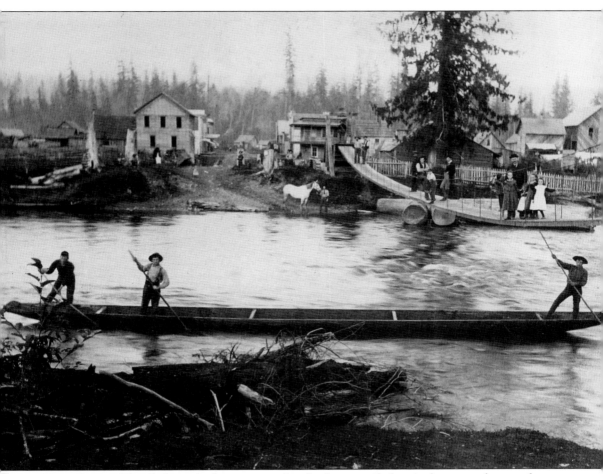

FIRST PEOPLE. The Skykomish clan was considered a distinct tribal entity by some ethnographers. They fished for salmon, hunted, and gathered throughout the valley prior to the arrival of white people. Known as fast walkers, they roamed the valley and used established summer camps throughout the hills seasonally. They wisely wintered, however, along the river between where Monroe and Index are today. They commonly traded with tribes east of the summit as well as coastal tribes. They were largely friendly and welcoming to white people. Per the Treaty of Point Elliott, signed in 1855, which subsumed the Skykomish people (including the Snoqualmie, Snohomish, and others) with the Tulalip, many moved to the Tulalip Reservation. Of those who remained, intermarriage, assimilation, and diseases brought by the whites reduced their number so that by 1950 there was little trace of them as a people locally. This photograph is from Sultan in about 1909. (Courtesy of Skykomish Valley Museum.)

EMPIRE BUILDER JAMES JEROME HILL. Hill believed the existing Northern Pacific Railroad was poorly managed and that he could build his own railroad to the Pacific Northwest and make money with it. He did and successfully exploited the riches of both the Northwest and the Orient, as well as settling farms and building states along the way. Hill's Great Northern Railway changed the face of Skykomish Valley forever. (Courtesy of Washington State Historical Society, 1924.50.1.)

ENGINEER JOHN F. STEVENS. Stevens chose to locate Hill's railroad along the South Fork of the Skykomish River. He went on to international acclaim as the locating engineer for the Panama Canal. (Courtesy of Georgetown University Library, Special Collections, Washington, D.C., John F. Stevens Papers.)

A Blaze on a Tree. After Stevens had recognized the Nason Creek route potential for the Great Northern Railway, he dispatched his assistant C. F. B. Haskell to confirm it. The route brought Haskell to the headwaters of the Skykomish, where he blazed the words "Stevens Pass" into a tree. In 1893, Norwegian photographer Anders Beer Wilse was documenting the building of the railroad and, knowing of Haskell's historic blaze, found and photographed it.

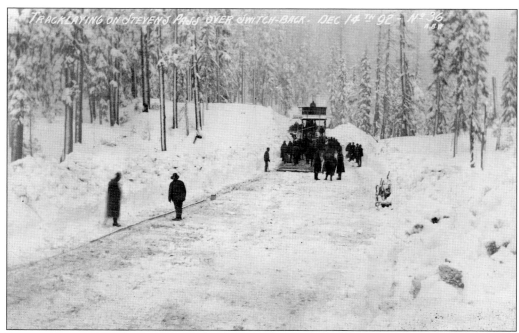

Laying Track on Stevens Pass over Switchback, December 14, 1892. Competition for the burgeoning trade with the Orient and the valuable mail route contracts put pressure on the Great Northern Railway to complete the shorter route to the Pacific in the least possible time, so track was laid throughout the winter of 1892–1893.

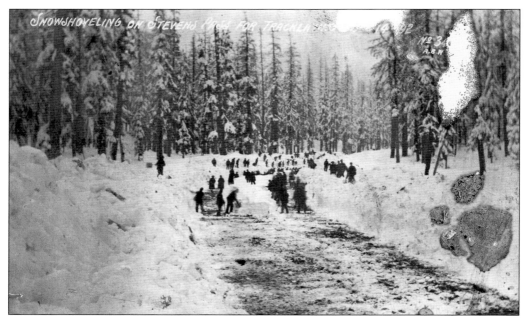

SNOW SHOVELING ON STEVENS PASS FOR TRACK LAYING, DECEMBER 14, 1892. James Hill's drive to complete his railroad meant small concerns like heavy snow were merely problems to be solved. Hire more people. Here there are two layers of shovelers; those on the roadbed threw snow up onto the bank, where a second crew chucked it out of the way to make room for more "roadbed" snow.

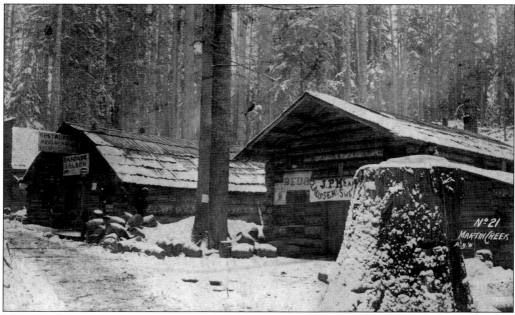

MARTIN CREEK, OASIS FOR HARDWORKING RAILROAD LABORERS. The signs say "Restaurant— Meals—Hours—Cheapest—Best—Town" (yes, "town") and "Cascade Saloon." Along with the "s" on "beds" being backward, another interesting historic aspect of the sign on the right is "Claussen & Sweeney Beer." Claussen and Sweeney became part of the team that spawned Rainer Brewery, one of two iconic beers in the Northwest throughout most of the 20th century.

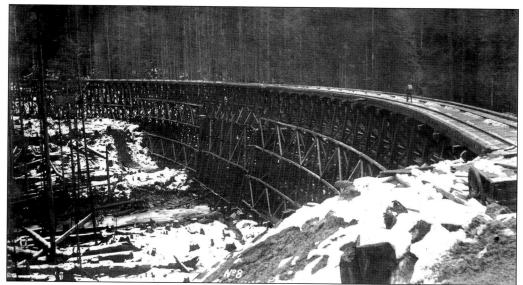

FOSS RIVER BRIDGE. As rails moved eastward from Seattle and westward from Wenatchee, local timber was cut, trimmed, and immediately put back near where it was cut in the form of trestles and bridges. Skykomish Historical Society records do not say if each bridge was engineered and a blueprint drawn up before construction or if each was merely "built" layer by layer by experienced men using their knowledge and an understood standard formula.

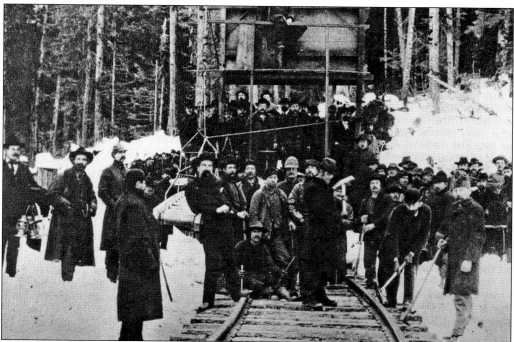

THE FINAL SPIKE. Unlike earlier transcontinental completions, the last spike was neither silver nor gold and was driven in the dark at 11:25 p.m. on January 6, 1893. This photograph is a reenactment in daylight for the camera. The most significant dignitaries were railroad executives, not politicians or business leaders. Aside from James Hill, few understood how this rail connection would ultimately transform Seattle and the Puget Sound area.

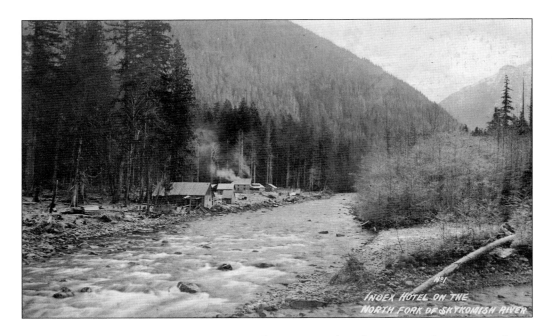

INDEX HOTEL. In the late 1880s, Amos D. and Persis Gunn bought a miner's claim just northeast of the main fork of the Skykomish River. They expanded the cabin to accommodate prospectors, who came in droves after hearing of ore strikes in the region. The settlement that grew around them became Index, named after Index Mountain, the dominant peak as one travels toward the upper valley from Sultan. In 1917, Mount Index was renamed Mount Baring. The Mount Index of today was called West Index Mountain until that time. The cable ferry seen on the next page was just east of the "barn" seen near the center of the map (below). (Map courtesy of Great Northern Railway Society Archives.)

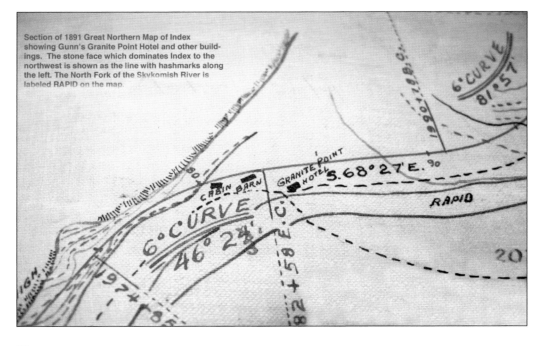

Section of 1891 Great Northern Map of Index showing Gunn's Granite Point Hotel and other buildings. The stone face which dominates Index to the northwest is shown as the line with hashmarks along the left. The North Fork of the Skykomish River is labeled RAPID on the map.

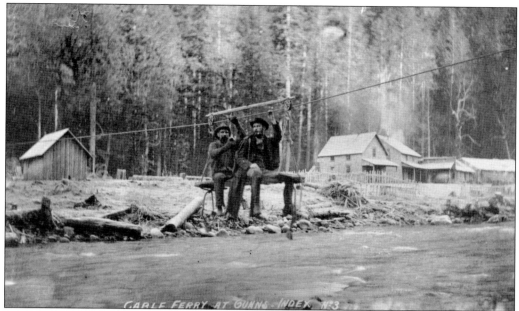

HOTEL AND CABLE CAR. The Gunns' hotel was called Granite Point, per Great Northern maps, and had 12 rooms. In 1893, the town was platted, and with the completion of the railroad, people came. The Panic of 1893 depressed development, but it meant hundreds of unemployed men became prospectors hoping to strike it rich. Index was the headquarters for several hundred miners and prospectors in the late 1890s.

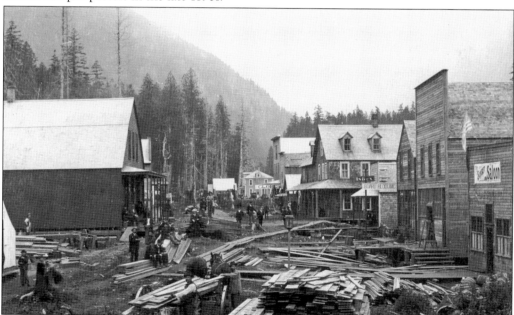

INDEX AVENUE A. This view is only a few years after the railroad was completed, looking east from the tracks. The Globe Hotel is in the center, its sign partly obscuring Amos Gunn's spiffy new gray home with white trim. Among the enterprises established in Index at the time was an assay office, and people were prone to refer to the place as Washington's "Butte," a reference to the copper mining mecca in Montana. (Courtesy of Index Historical Society.)

JOHN MALONEY. Hired on from his homestead at Lake Chelan as a packer for John F. Stevens, Maloney recognized an opportunity when the railroad was routed through Skykomish Valley. He staked a claim along flat land and a bend in the river 16 miles west of the summit in 1891 and began preparing for the railroad to arrive. He remained a key figure in Skykomish Valley for four decades.

GREAT NORTHERN RAILWAY MAP, 1891. John Maloney's cabin may be seen at the upper right. Little is known about H. Wohlgothen, whose cabin is at lower left. The arrow-like spur angling away from the tracks at center right is "Coal Track," and the parallel track separate from the others is "House Track." The photograph on the next page was taken from just off the lower left corner. (Courtesy of Great Northern Railway Society Archives.)

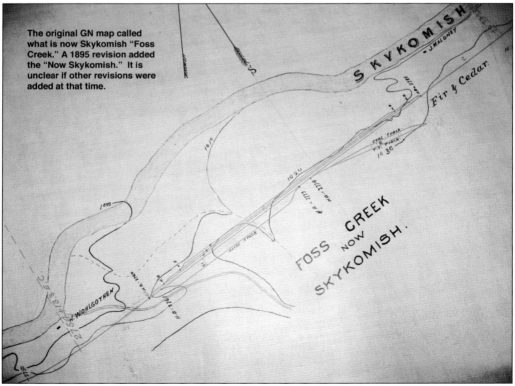

The original GN map called what is now Skykomish "Foss Creek." A 1895 revision added the "Now Skykomish." It is unclear if other revisions were added at that time.

Skykomish, June 12, 1894. This Wilse photograph from west of town names Skykomish six years before the town plat was recorded. Note the new, square railroad ties and log culvert. Great Northern originally called Skykomish "Foss Creek" but later renamed its station to Skykomish in February 1893, the same year the Skykomish Post Office opened. It is not known when Foss Creek itself was renamed Maloney Creek. In any case, Skykomish grew quickly once the railroad was completed.

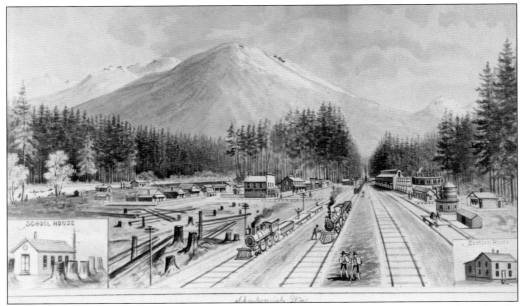

A Town Is Formed. The photograph below essentially confirms the accuracy of the "sketch" of Sky (above) about 1898, allowing for some odd artistic license items like the gypsy musicians between the tracks, the "POST OFFICE" sign along the wall of the store, which would have had to be in letters three feet high, and people dancing on the flat cars of the moving train. The store, the first hotel, and commercial buildings beyond are nearly identical in both. The inset section house is still standing and privately owned today. At left near the river, the stanchions holding the footbridge (next page) may be seen, but John Maloney's shingle mill has not yet been built. The "power" poles seen in both are for telegraph and/or telephone wires, not electricity. (Below, courtesy of Dave Sprau.)

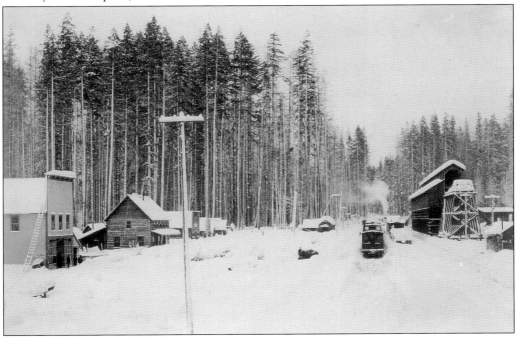

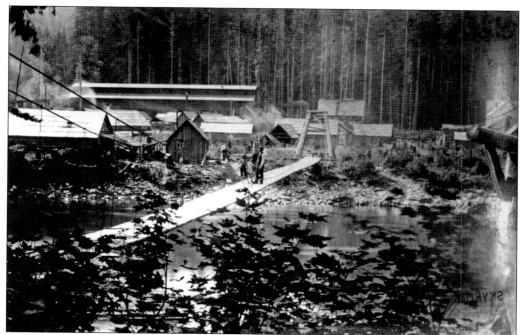

FIRST BRIDGE IN SKY. About 1900, this was roughly where today's bridge stands, photographed from where the Chevron station is now. John Maloney's shingle mill is on the left. The long building at back left is the Great Northern Coal Tower. The taller building above the bridge stanchion is the first Skykomish Hotel, and at far right in the faded area is the corner of the store.

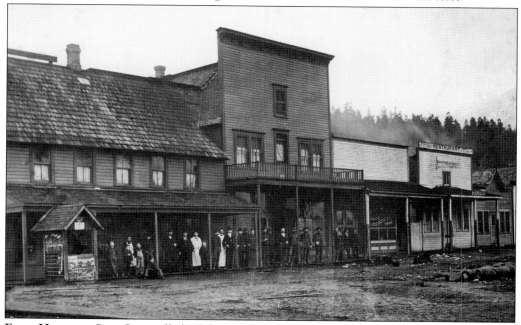

FIRST HOTEL IN SKY. Originally built by Frank Wandschneider as a log building, the hotel was expanded and given a new facade about 1900, as shown here. Accounts differ; it may have burned in 1902 and been rebuilt, then burned again. In any case, the final replacement after the April 1904 fire was the Skykomish Hotel as it stands today on the same ground.

by

L. K. Hodges. Sea. P-I. 1897

MILLER RIVER.

Although the people of Seattle are too broad-minded and energetic to confine their efforts to the development of the mining districts of their own county, the district drained by the streams flowing northward into the Skykomish south fork has a peculiar interest for them, for it is close to their home and in King county. To arrive at it, they have only to take the Great Northern train to Skykomish, eighty-five miles, and then go by road five miles, and by trail two miles further, to reach the head of Miller River, to which the road will be extended this summer. Skykomish is distant fifty-two miles from the Everett smelter and 126 miles from the Tacoma smelter.

If any man has any doubts as to the strength and permanence of the ledges of this district, he has only to visit them and he will be convinced. The country rock on the backbone of the ridge in which the ledges are found is granite and syenite, and the mineral-bearing rock has filled fissures in these strata, only to be worn down by snow and water as it is decomposed by the action of the air, leaving perpendicular walls 100 to 200 feet on each side. Thus the ledges are usually found in the beds of narrow gorges in the basins at the head of the streams or on the sides of the mountains which form the canyons, and are easily traceable from base to summit of the range. The ledge matter is generally porphyritic quartz, often so uniformly mineralized as to pay for concentration on the ground, and carries pay streaks rich enough to pay for shipment, even with the present costly means of transportation to the railroad. The ore carries iron and copper sulphides, gray copper and galena, carrying gold and silver, the pay streaks giving usually from $50 to $60 a ton, the second grade ore from $10 to $20. Some of the ledges, however, are much richer, those on the Cleopatra Basin carrying several hundred ounces in silver, and those near the summit over-looking that basin running high in copper. Further northward, towards the mouths of the streams, are dikes of diorite, in which occur ledges of pyritic ore carrying native copper and gold near the surface; also dikes of dolomite and porphyry with ledges of sulphide and gray copper ore. The ledges of pyrites are heavily capped with magnetic iron and are rich in copper and gold and often carry silver.

Prospecting in this district began while the Great Northern Railroad was under construction in 1892, by W. L. Sanders and Archie Williamson, and successive discoveries have shown such wealth that active development by outside capital is in progress and the district can now boast of the possession of the second power-drill plant in the Cascade mountains. Its principal mine, which is being developed by this plant, has already made large shipments giving conclusive evidence of its value. This is the Coney mine, owned by the Baltimore & Seattle Mining & Reduction Company. It is on the basin at the head of Coney Creek, which flows into Miller River from the west and is six miles from the Great Northern Railroad. The group consists of nine claims on three parallel ledges running diagonally up the basin to the summit, ten, seven and six feet wide respectively, two of them uniting on the summit in a blow-out 100 feet wide and all three being traceable across to the Snoqualmie side of the divide. A strong spur runs up the center of the basin into this series of ledges and is the point where development began. The ledge matter is porphyritic quartz carrying auriferous galena and iron sulphides between syenite walls. The spur above mentioned cropped five feet wide on the surface and a tunnel has been run along it for 225 feet. This tunnel cut an ore chute thirty feet long and five feet wide forty feet from the mouth, and eighty feet further the ledge widened to fourteen feet wide, half of which was good ore. From the first chute forty tons was shipped in 1895 and returned $58.70 per ton over freight and treatment. In the fall of 1896 a power drill plant of three drills operated by compressed air was installed, power being generated by a dynamo driven by a water wheel at the falls of Coney Creek and conducted to a motor in

EARLY MINING. This is from an 1897 *Seattle Post-Intelligencer* book, *Mining in the Pacific Northwest.* Photographs of early mining are rare, but the names of many of the people involved in mining will appear elsewhere in this book; John Stevens, John Maloney, John Soderberg, William Timpe, Hugh McIntosh, and Frank Wandschneider all dabbled in mine "ownership" in the early years.

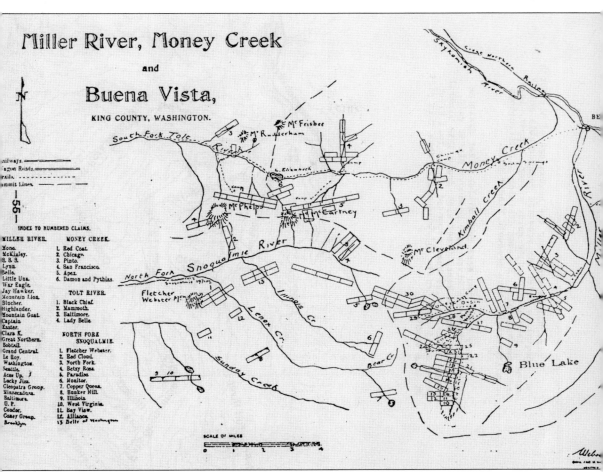

Miller River, Money Creek

and

Buena Vista,

KING COUNTY, WASHINGTON.

N

Railways.
Wagon Roads.
Trails.
Summit Lines.

INDEX TO NUMBERED CLAIMS.

MILLER RIVER.

Mona.
McKinley.
S. S. S.
Lyon.
Bella.
Little Una.
War Eagle.
Jay Hawker.
Mountain Lion.
Blucher.
Highlander.
Mountain Goat.
Captain
Easter.
Clara K.
Great Northern.
Grand Central.
Le Roy.
Washington.
Seattle.
Acme Up.
Lucky Jim.
Cleopatra Group.
Minnecalema.
Baltimore.
U. P.
Condor.
Coney Group.
Brooklyn.

MONEY CREEK.

1. Red Coat.
2. Chicago.
3. Pinto.
4. San Francisco.
5. Apex.
6. Damon and Pythias.

TOLT RIVER.

1. Black Chief.
2. Mammoth.
3. Baltimore.
4. Lady Belle.

NORTH FORK
SNOQUALMIE.

1. Fletcher Webster.
2. Red Cloud.
3. North Fork.
4. Betsy Ross.
5. Paradise.
6. Monitor.
7. Copper Queen.
8. Bunker Hill.
9. Illinois.
10. West Virginia.
11. Bay View.
12. Alliance.
13. Belle of Washington.

SCALE OF MILES

0 1 2 3 4

South Fork Tolt River

Mc Frisbee

Mc R. Wickerham

L. Elizabeth

Money Creek

Mc Phelps

Mc Eartney

Mc Cleveland

Kimball Creek

Miller River

North Fork Snoqualmie River

Innes Cr.

Fletcher Webster Mine

Lenox Cr.

Bear Cr.

Sunday Creek

Blue Lake

MINING DEVELOPMENT. Five pages of *Mining in the Pacific Northwest*, including this map, were devoted to mining operations along Miller River and Money Creek alone, detailing what was being produced and how much development money had already been spent. History indicates that by the end at least as much money was put into the ground in the region as came out of it in processed minerals. When the railroad arrived, the hills came alive with prospecting and development.

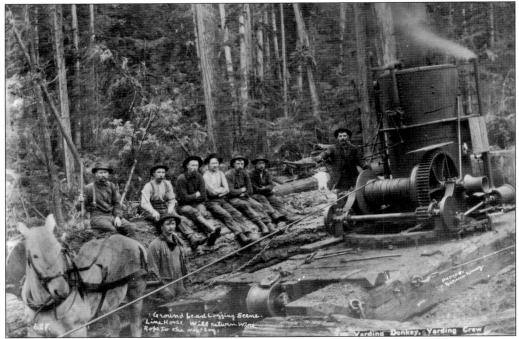

HORSE AND DONKEY LOGGING. As expansion and enterprise ground their way up the valley, lumber was needed for the railroad, for building, and for the numerous mining operations that were expanding into many areas. In the operation shown here, the horse pulled the line out into the woods where it was attached to a log, then the donkey yarded it back to a landing. (Photograph by Darius Kinsey; courtesy of Whatcom Museum, 1978.84.322.)

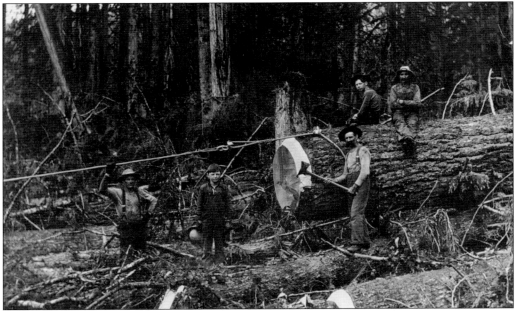

BEVELING A LOG. The very early logging was all ground lead, where logs were yarded along the ground, being followed by the crew to snake them past stump and rocks as necessary. By chopping a bevel around the leading end of a log, many "hang-ups" were avoided. (Courtesy of MOHAI.)

26

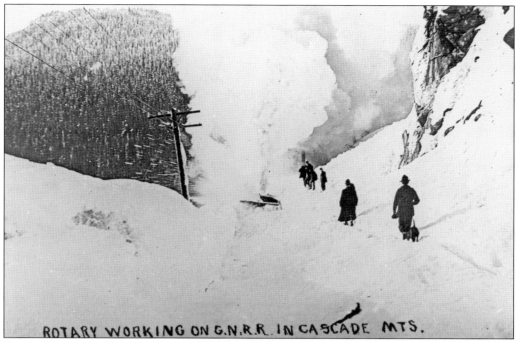

ROTARY WORKING ON G.N.R.R. IN CASCADE MTS.

GREAT NORTHERN RAILWAY. Jerome Hill's line and his enterprise and entrepreneurship may have put Puget Sound cities on a new course, but it was not an easy line to operate. Rotary snowplows could carve through snow up to 13 feet deep. Deeper slides required teams of men with shovels to bring the level down. Rotaries also needed space to throw snow, so when walls got too high, it again took hand labor to make room. Snow shoveling and other unskilled labor at the time paid less than 20¢ per hour, and room and board often came out of it, but there was no shortage of labor.

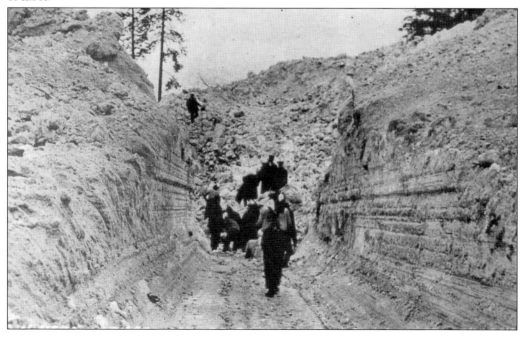

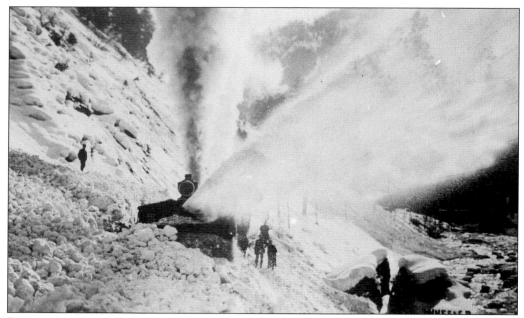

ROTARY SNOWPLOW AT WORK. As impressive as this photograph is in terms of power and grandeur, the sound rotaries generate is said to be their most impressive feature, aside from removing snow, of course. To keep the switchbacks open, a short train was made up of a rotary at each end and two locomotives in the middle. Nearly every winter presented storms where they could not keep up.

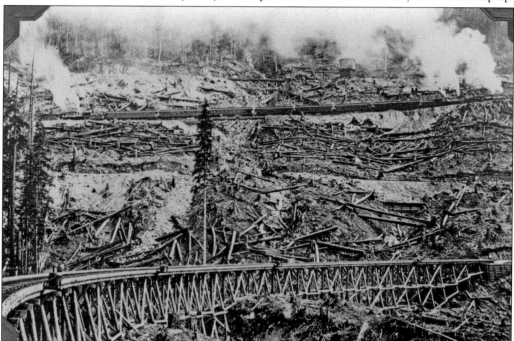

THE SWITCHBACKS. This photograph shows four levels of the switchbacks between Wellington and the summit. Cars were moved in units of eight, with engines on each end. In ideal conditions, this took one and a half hours. Often it was longer. U.S. Highway 2 now runs just below where the train appears in this photograph.

28

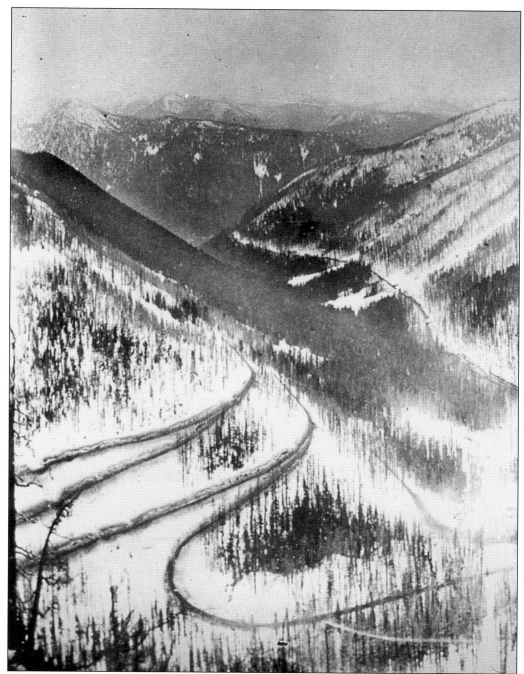

Almost an Aerial Photograph. To take this picture, a railroad photographer slogged his 1890s state-of-the-art photographic equipment in deep snow to Skyline Ridge, a mile northwest and 1,500 feet higher than the summit at Stevens Pass to capture the grandeur of the switchbacks. They were hailed at the time as an engineering marvel, and they did fulfill Jerome Hill's demand for the shortest route to Puget Sound, but even before workers were finished, John F. Stevens began planning a tunnel to replace the switchbacks. Wellington is just out of the photograph at the lower right, but parts of the original snow sheds can be seen angling down toward Windy Point.

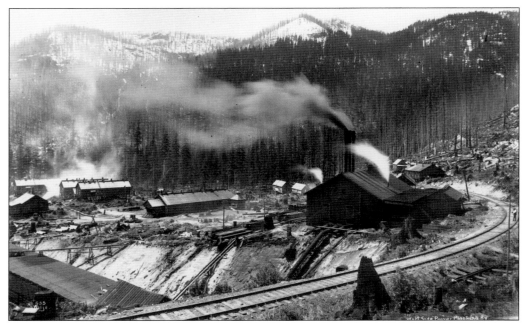

CONSTRUCTION CAMP AT WELLINGTON. This camp supported construction of the 2.6-mile Cascade Tunnel around 1898. The large building is the power plant. The dark, low foreground building is a shed for snow protection over the entrance to the tunnel. Other buildings include quarters, a dining hall, and a hospital. A cement plant would be added later to produce cement to line the tunnel. (Courtesy of MOHAI.)

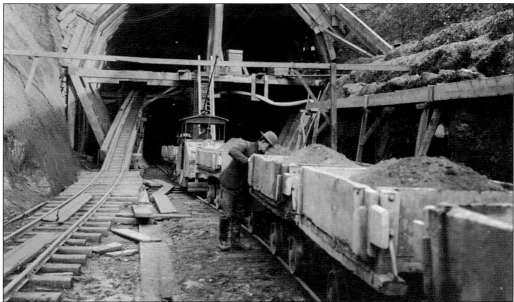

SHORING THE TUNNEL. Much of the west end of the tunnel was dug through "slide" material, which, unlike rock, needed significant shoring to keep from caving in. Three and four layers of 10-by-10 timbering and tons of concrete were needed to complete the job. The tunnel opened on December 10, 1900, saving 8.5 miles of track, 2,332 degrees of curvature, and 734 feet of elevation. The switchback era was over. (Courtesy of MOHAI.)

Two

1900–1910

Between 1900 and 1910, the population of Washington more than doubled to 1.1 million inhabitants, and many of those people found work in the valley.

Great Northern Railway continued to employ vast numbers both for its daily operational requirements and to refine and improve the hastily constructed rail lines during the previous decade. The original long, high, wooden trestles at Martin Creek and Foss River were replaced by steel bridges in 1900 and 1901.

The opening of the 2.6-mile Cascade Tunnel at Wellington in 1900 ended the employment of 800 workers and reduced the numbers of operational employees required to shepherd trains across the switchbacks broken into eight-car sections, but building snow sheds, electrification of the tunnel, and the additional track and rail yard required to accommodate the electrics needed to be engineered and built. The electrics came on line in 1909.

Mines were operating and expanding along the North Fork of the Sky and up Miller River, Money Creek, and Foss River. An account from *Discovering Washington's Historic Mines* says that, around the dawn of the 20th century, Apex Mine spent about $100,000 to develop the mine, its encampment, and its transportation systems, and in 1901, $80,000 worth of ore was produced. In its heyday, the Ethel Mine above Index sported a bunkhouse and cookhouse, two dwellings, a 10,000-board-feet-per-day sawmill, two stables, an 80-ton-per-day ore concentrator, and an electric power plant.

Sawmills sprang up all along the railroad; many were single-product enterprises where the output found immediate local use as mine timbers, snow sheds, or building materials. In some cases, the communities preceded the mills; in some cases, communities followed.

Although the majority of workers were unaccompanied men taking jobs where they were available, at the same time, communities were growing up and down the valley. In addition to Skykomish and Index, by 1910, there were schools in Baring, Grotto, Berlin (Miller River), Alpine, and Wellington.

Tourism also contributed to the economy as people came by rail on scheduled trains as well as special weekend recreation trains to fish, hunt, hike, picnic, and pick berries. Destination resorts such as the Scenic Hot Springs Hotel and the Miller River Inn offered "package deals" to tourists from Puget Sound and elsewhere.

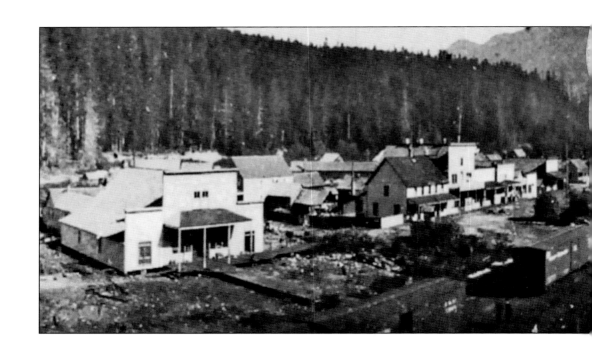

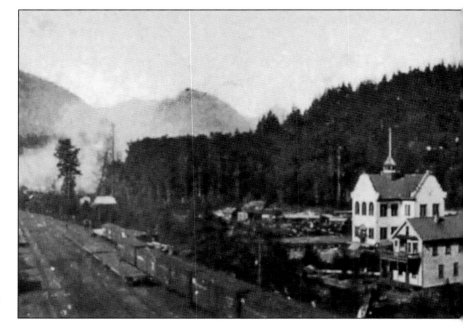

LOOKING NORTHWEST. A panoramic of Sky from the same water tower as above features the new school built that year, slightly west of where the school built in 1936 stands today. At left rises smoke and perhaps steam from the mill at Milltown. The timber across the river had not yet been logged.

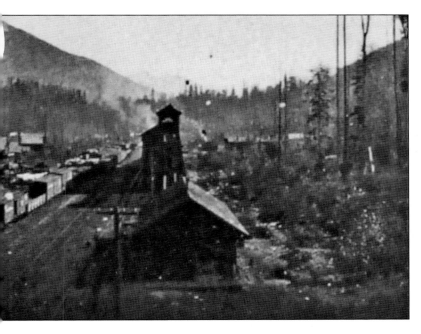

SKYKOMISH BEFORE THE FIRE, 1902. The "store" is considerably larger than the "hotel," but the other storefronts facing the tracks are essentially as they looked until the 1970 fire. Except for the long low roofline in the distance, little south of the depot and coal chute appears developed.

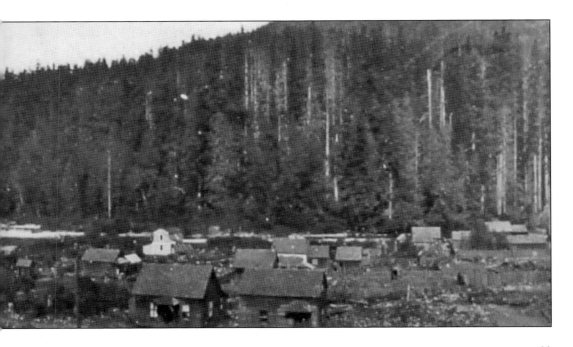

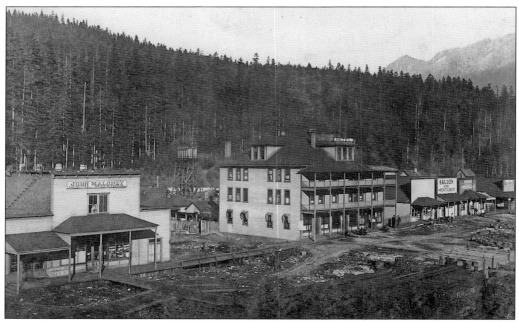

A FINE NEW HOSTELRY. After the 1904 fire, the Skykomish Hotel was rebuilt as a "fine four-story" establishment "plastered throughout and neatly and comfortably fitted and furnished." One likely reason to expand the hotel was Skykomish's role as a division point for the railroad. In winter, eastbound trains were often "held" while awaiting snow removal on the tracks, intermittently delivering hotel and restaurant clients in what might otherwise be a quiet season.

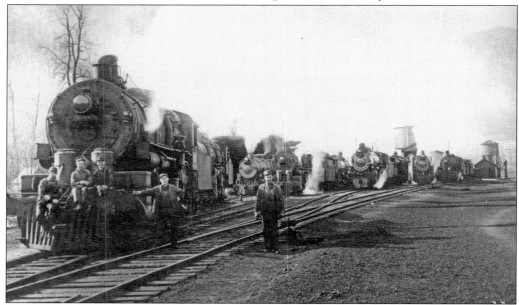

FIRED UP AND READY. Eight engines await assignment at the Skykomish roundhouse. The grade between Seattle and Skykomish did not exceed one percent, but east of Sky, it steepens to 2.2 percent. A single "Consolidation" steam engine could pull a 25-car train from Seattle to Skykomish, where it would be replaced by a new crew and two fresh locomotives, one pulling and one pushing, for the climb over Stevens Pass.

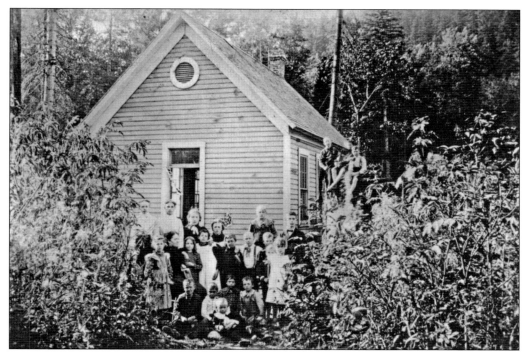

FIRST SKYKOMISH SCHOOL. The earliest known records of formal schooling in Skykomish date from 1893 with an enrollment of five. It is not known when this purpose-built school was erected, but it was outgrown and replaced by the school pictured below in less than a decade.

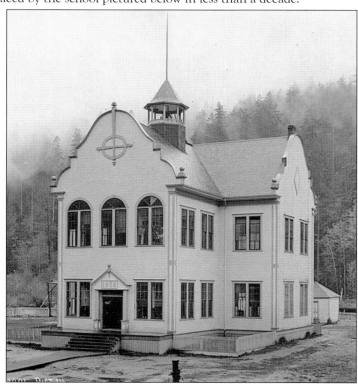

NEW SCHOOL, 1902. Sky replaced its one-room school with this "handsome two-storied, wood framed building with Flemish Parapet detailing." The parapets of hundreds of "Cape Dutch" buildings in South Africa look much the same. Just exactly why this almost regal, opulent style was seen to fit the Skykomish profile can only be speculated upon, but it seems indicative of the "anything is possible" mentality of the new century.

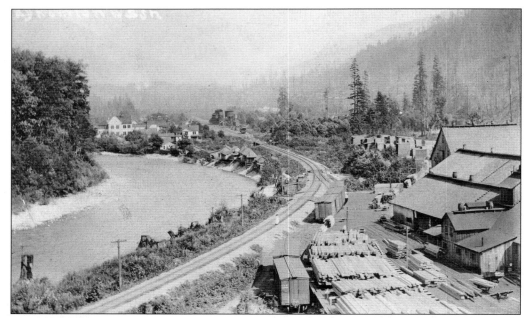

SKYKOMISH FROM MILLTOWN, C. 1905. Always a major employer, the Skykomish Lumber Company Mill had plenty of lumber in stock when this photograph was taken. Tall alder trees grow in that area today. One can only speculate what the flues running down from behind the cabins to the river might have been, but a gravity-feed sewer system seems a likely explanation.

SKY FROM THE BASE OF MALONEY MOUNTAIN. A logging railroad passes several hundred yards above town to the south in this c. 1905 photograph. A plume rises from John Maloney's shingle mill near the center, and more smoke and/or steam can be seen coming from the mill at the far left. Dwellings are visible among the stumps and snags south of the Great Northern mainline tracks. (Photograph by Darius Kinsey; courtesy of Whatcom Museum, 2001.23.3.)

INDEX, C. 1901. Avenue A, with its wooden boardwalks, runs the length of the town center. It is shown at ground level in a photograph taken from near the railroad tracks on the next page. The large Gunn home is on the left between Avenue A and the river. The Index depot is the diagonal building along the tracks at bottom right. The original Bush House, before it was expanded, is the third building to the left of the station, at the end of the wide boardwalk; the addition was added to the east, at a right angle to this roof line.

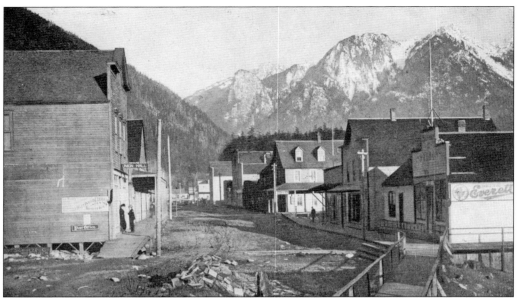

AVENUE A, LOOKING EAST. The building in the center with the two dormers is the Globe Hotel; the post office and a meat market are beyond in the shadows. At right is the Sunset Saloon with "Everett Beer" emblazoned on its side. At left are a dry-goods store, the miner's hall sporting a "Union Hall" sign, and John Soderberg's hardware store.

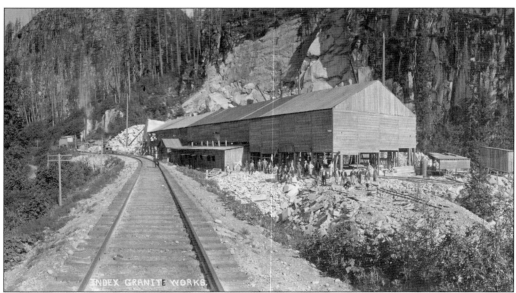

WESTERN GRANITE WORKS. A major Index employer beginning in 1904, Western benefited greatly from its proximity to the Great Northern Railway. The Washington State Capitol steps are made from Index granite, as well as many building foundations and curbing in Seattle and elsewhere. Between the Great Depression putting a damper on building in general and cement being used in foundations, all valley granite quarries ceased operation by 1932. (Courtesy of Washington State Historical Society.)

BUSH HOUSE, LANDMARK SINCE 1898. In her book *Stevens Pass*, author Jo Ann Roe wrote, "In those days the GNR conductor announced 'Bush House' as a scheduled stop, and passengers were met by Mrs. Clarence Bush herself." Roe goes on to report per a news clipping that William Jennings Bryan was a guest in November 1908.

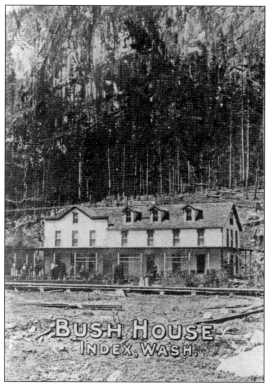

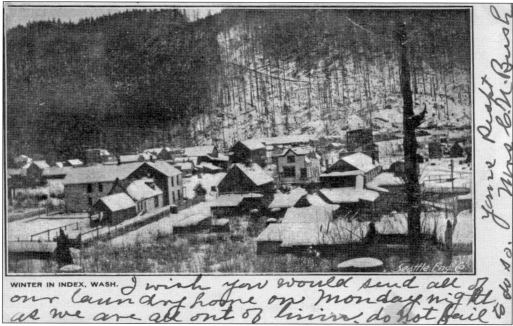

A POSTCARD TO MONROE. On Sunday, June 18, 1907, Ella Bush posted this card telling cleaners to send the laundry "by Monday." Day to day, people shopped locally; nonetheless, mail and goods moved efficiently up and down the valley. With several mail trains a day each way, a card on a Sunday could produce linens on a Monday, in time to change the sheets for the new guests.

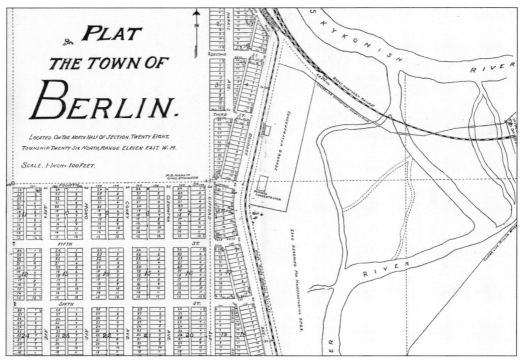

TOWN PLAT OF BERLIN. With numerous mines operating, or attempting to, up both Miller River and Money Creek, this ambitious town plat for Berlin was filed in 1900. It featured seven avenues (four named after mines: Apex, Cleopatra, Coney, and Mono), seven numbered streets, more than 500 lots, a sawmill, a vast plot for ore concentration, and a space of reserved land between Deupree Avenue and the river for "future manufacturing sites."

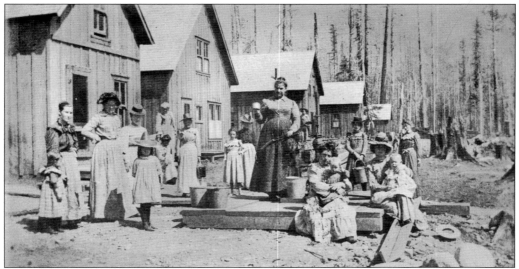

TOWN PUMP AT BERLIN. Most early valley communities that disappeared were railroad towns. Berlin (Miller River after 1917) was a mining town that was wiped out by a forest fire in 1906. The 1922 Skykomish School yearbook placed the population around 500 before the fire. Perhaps it appeared mining would not support the early promise the town had been built upon, as it probably never reached one-fourth that size again. (Courtesy of Margaret Smith collection.)

40

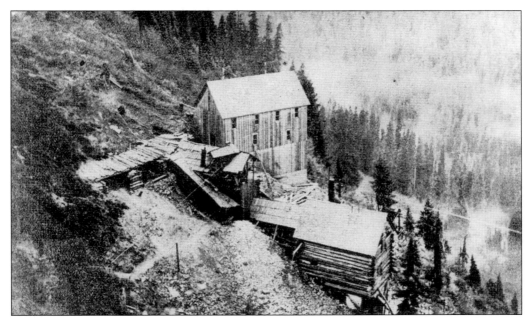

CONFLICTING ACCOUNTS OF EARLY MINING. It is unclear if John Maloney financed its discovery or bought into the Apex mine (above) later along with partner John F. Stevens. Did the reported $80,000 worth of ore out of the Apex in 1901 really come by packhorse, as some accounts report? Did Andrew McCartney really put $100,000 (of 1900 dollars) into the mine without building a railroad from Berlin to the base of the tram? Then again, if the ore car pictured below is an entire rail shipment, a string of horses might have handled it. The Apex operated intermittently for decades, producing $300,000 in ore, and it is said there is still gold in the Apex; however, the fact that arsenic is embedded in the ore matrix has of late made the mine impossible to operate profitably. (Both, courtesy of Daryl Jacobson collection.)

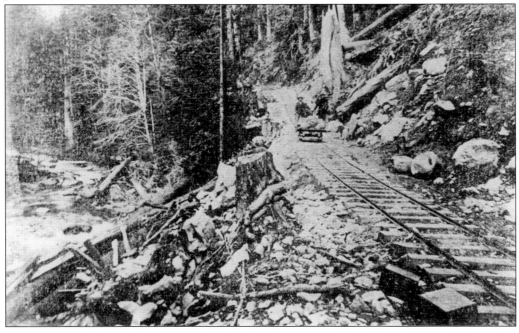

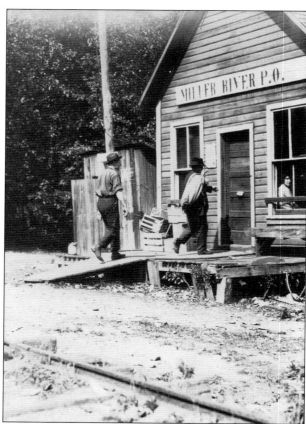

POSTMASTER BRINGS THE MAIL BAG. Accounts differ, but the 1906 fire is said to have wiped out an ore concentrator, several small mills, two hotels, two stores, numerous saloons, an assay office, and all the houses in Berlin. Postmaster Millard Fillmore Smith, shown here, was one of the few to return. He built and operated the Miller River Inn for the next several decades. (Courtesy of Margaret Smith collection.)

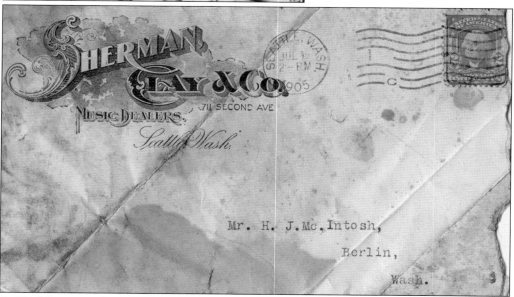

A 1905 SHERMAN CLAY AND COMPANY MUSIC DEALERS ENVELOPE. Doyle McIntosh believes his grandmother Mae played piano, but in any case, it is indicative of life in the era. Before radio or gramophones, people made their own music in their homes and in small groups. Popular song sales were in the form of sheet music, and people vied to be the first to play a new hit.

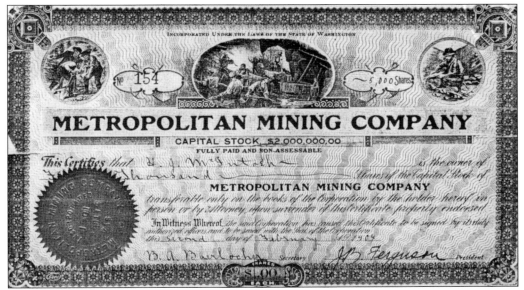

FIVE THOUSAND SHARES OF METROPOLITAN. In 1907, Hugh McIntosh was superintendent of the Metropolitan Mining Company and vice president of the Superior Mining Company, both of Berlin. He came to the valley from Canada as a Great Northern section foreman but soon began mining. Between 1895 and 1907, he filed more than 40 mining claims. Most of the money he made mining was from selling those claims. Also in 1907, McIntosh worked for wages at the Skykomish Lumber Company. (Courtesy of Doyle McIntosh collection.)

TWO IMMIGRANTS. Next to Canadian Hugh McIntosh (seated, far right) is Hungarian George Koch (seated, second from right), who came to Ohio in 1902 and, after several stops, ended up at the Skykomish Lumber Company logging camp. When his younger brother died in Hungary, George returned in 1908 to console his mother. While there, he was forced to serve in the army, and when that was finished, he married and returned to the United States in 1910. (Courtesy of Doyle McIntosh collection.)

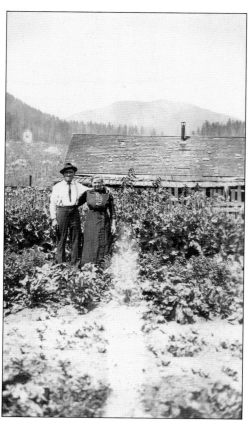

George and Katie Koch in Their Garden. After returning to Skykomish with his bride, George worked logging until an injury caused him to join the Great Northern Railway as a roundhouse machinist's helper. He stayed 34 and a half years, retiring in 1954. The Kochs and their children also operated a dairy, delivering milk in town, and sold garden produce. In 1932, they built the nicest house in Sky. (Courtesy of Rose Marie Koch Williams collection.)

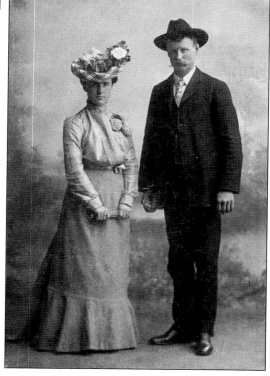

A Wedding in Seattle. Hugh and Mae (Lewis) McIntosh were married at Stephen's Hotel in May 1902. They met and courted in Berlin (Miller River), lived there, and had two sons before the 1906 fire, after which they moved to Skykomish, where a third son was born. When opportunities in the mining business lost their glow, they moved to Nebraska near Mae's family, where three more children were born. (Courtesy of Doyle McIntosh collection.)

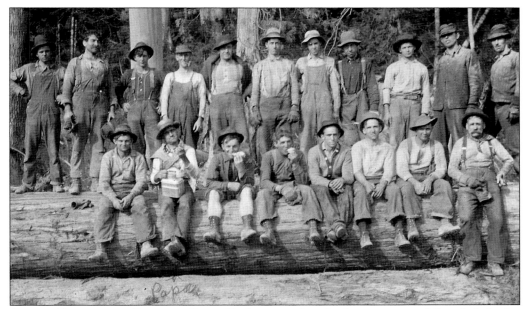

GEORGE KOCH WITH A LOGGING CREW. Koch is seated in the first row, second from left. It also could be that one or two of the ballplayers pictured below worked on this crew. They would work six days a week and go to the ball park on Sunday to play or watch. Note the face and posture of the third man from the left in the second row compared to the young man of similar placement in the photograph below. (Courtesy of Rose Marie Koch Williams collection.)

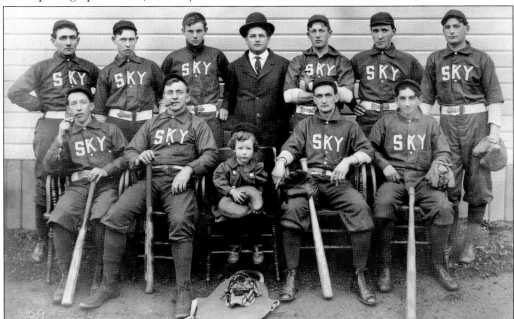

SKYKOMISH BASEBALL TEAM, C. 1907. It is not known if it is the same gent in this picture and in the one above, but the caption given with the photograph says the mascot is Forest W. Farr. Paul Fournier is the manager, although the caption says only, "The town barber, in plug hat center of back row, was the manager." (Courtesy of Whatcom Museum, 2001.0023.10; photograph by Darius Kinsey.)

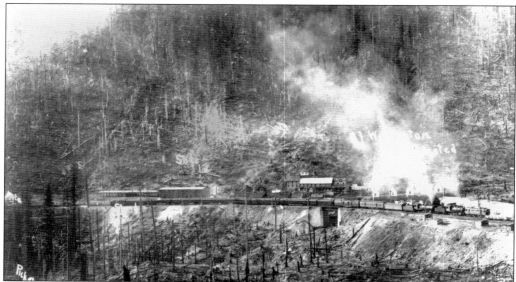

A Boomtown. Wellington bustled throughout the decade as a center for track maintenance, snow removal, snow shed construction, hostling engines on and off trains, and the conversion to electrification of the tunnel. The first Cascade Tunnel opened in 1900 and solved the problem of the switchbacks but created problems of its own, particularly for eastbound trains. The 1.7-percent grade meant steam engines had to pull the full 2.6 miles, and the resultant exhaust fumes were toxic on windless days. After several deaths and some near-miss episodes, Great Northern decided the tunnel needed to be electrified. Work began on a dam in Tumwater Canyon on the Wenatchee River to produce the required power in 1907, and by 1909, all wiring, catenary, and the redesigned rails yard to accommodate switching between steam and electrics for the 6-mile run were completed. The 6.2 miles of electrification is said to have been the shortest section of electrified mainline ever made.

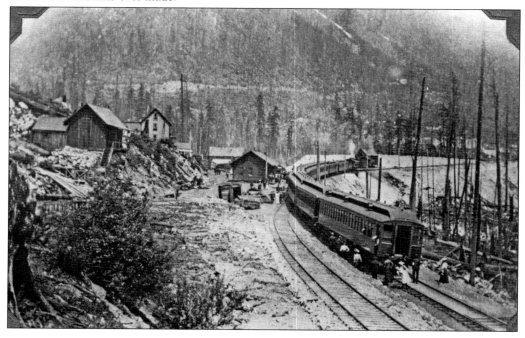

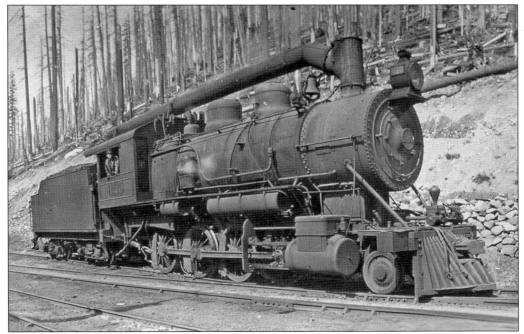

MODIFIED LOCOMOTIVE SMOKESTACK. The smoke and fumes from boilers of steam engines were more than a health hazard for rail workers and passengers in the Cascade Tunnel; at times, they represented a death threat. This experimental design did not solve the problem, as few other locomotives were so modified, and this stack configuration went quietly out of service not long after it began and well before electrification of the tunnel.

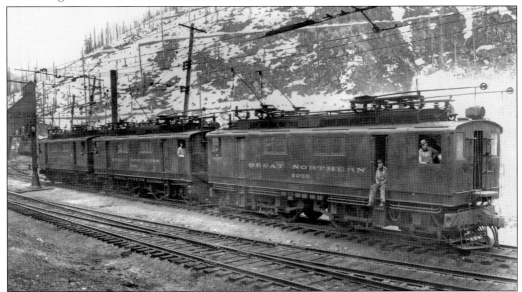

FIRST GN ELECTRICS. Working in pairs, the streetcar-looking little engines moved trains through the tunnel at 15 miles per hour. As trains got longer, it became necessary to divide them in two because the system lacked electrical power for more than two engines at once. This was solved by running all four engines at half speed, so trains would not have to be split to traverse the tunnel.

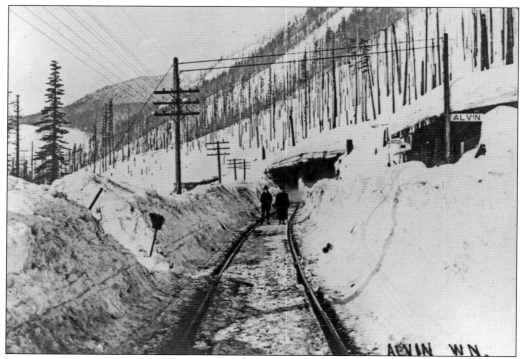

MILES OF SNOW SHEDS. The Cascade Tunnel removed 8.5 miles of track requiring snow removal each winter, but snow remained a problem. Snow sheds, such as the one here at Alvin a few miles west of Wellington, needed to be built and maintained. In summer, sparks from steam engines set fire to the trees that lined the tracks. Railroad brochures circulated in the East suggesting people come west and see the show for themselves.

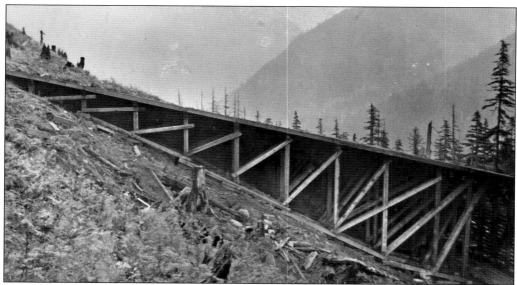

LABOR AND TIMBER INTENSIVE. Each summer, the Great Northern Railway added snow sheds to protect the tracks and reduce the amount of snow needing removal from the tracks in winter. Blending into the hill on the left, the shed was designed to allow snow slides to move across the roof and fall beyond the tracks on the right.

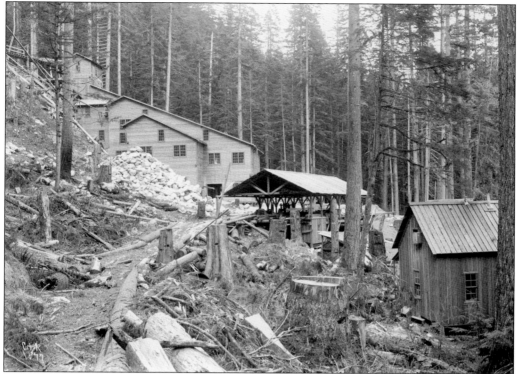

ALL LOCAL TIMBER. This photograph is of the ore concentrator at either the Ethyl Mine or the Copper Belle Mine (museum experts disagree), both of which were near Index. In any case, it is indicative of the aboveground uses of locally cut timber in mining. Even more timber went into the ground as shoring and cross ties in tunnels. (Courtesy of Washington State Historical Society.)

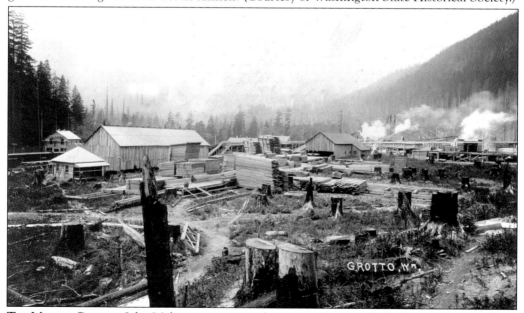

THE MILL AT GROTTO. John Maloney was among the owners of this mill, which operated throughout the decade supplying lumber for both local use and shipment elsewhere.

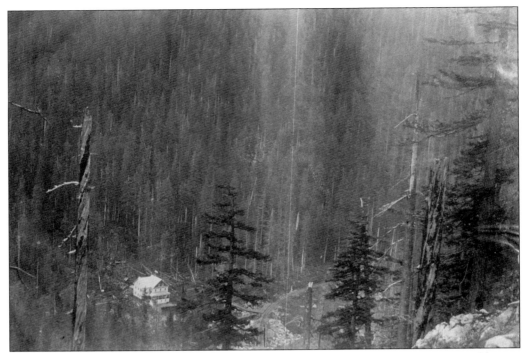

SCENIC HOT SPRINGS. The original "Great Northern" Hot Springs Hotel was built in the wilderness above the Madison (later Scenic) station before the dawn of the 20th century. It boasted 50 guest rooms on the upper floors and hot spring "healing" waters piped into baths on the ground floor. A resort brochure stated, "No other medicinal water in the West is so effective for the cure of rheumatism, stomach, liver, bladder, blood, and skin diseases!"

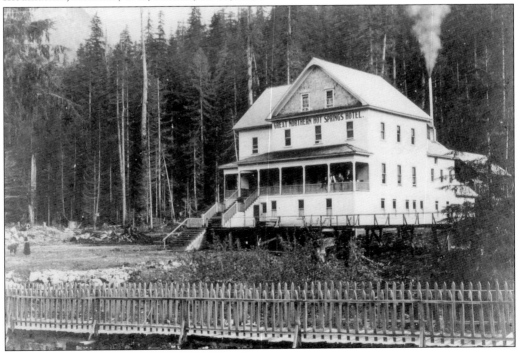

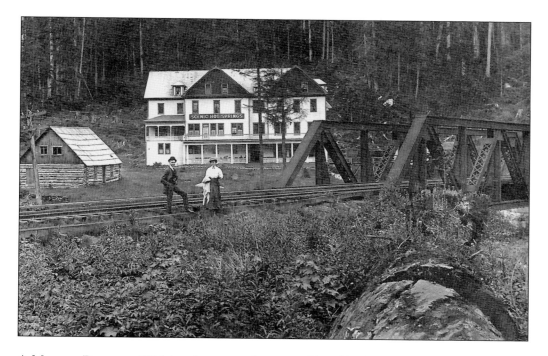

A MASSIVE REMODEL. Within a few years, the original hotel had been nearly tripled in size (as pictured above) and renamed the Scenic Hot Springs Hotel. A Seattle newspaper reported it was furnished in oak and had electric lights, steam heat, call bells, and the best of dining room service; guests could play billiards, lawn tennis, handball, croquet, and basketball. In December 1908, this hotel burned to the ground, yet within six months, a new chalet-style hotel (pictured below) was built and open for business the following June, in time for the Alaska-Yukon-Pacific Exposition, which was attended by more than 3.7 million visitors.

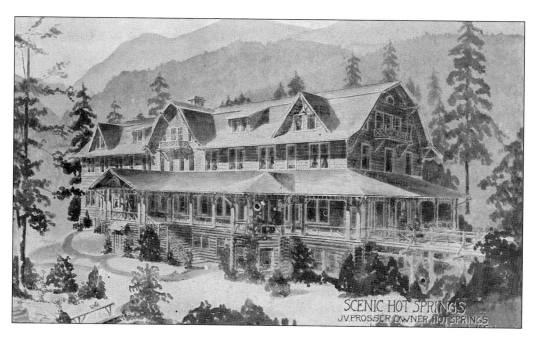

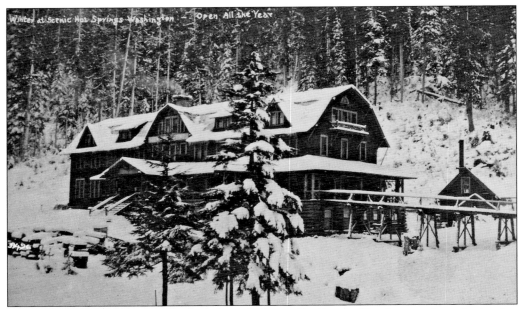

IN CHALET STYLE. The speedily built chalet-style Scenic Hot Springs Hotel operated as a destination resort in both the summer and winter for nearly 20 years. In addition to the regular east-west rail service, special weekend tourist trains brought fishermen, hunters, hikers, berry pickers, skiers, and other vacationers to Scenic. "Progress," however, ended its successful run. The Scenic Hot Springs Hotel found itself in the path of the GN rail line as it exited the new 8-mile tunnel and, after providing meals and respite for the crew that built the tunnel, was essentially buried by the new rail bed in 1929.

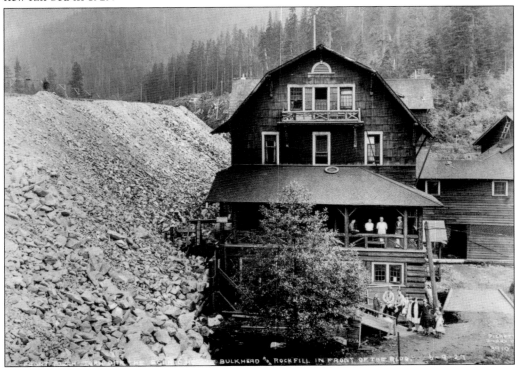

Three

1910–1920

In March 1910, Skykomish Valley made worldwide headlines. The worst avalanche disaster in U.S. history, and nearly the worst U.S. train disaster as well, happened at Wellington. The story of two westbound GN trains stranded near the summit of Steven's Pass captured more and larger headlines daily for nearly a week. After several days at the Cascade Tunnel Station on the east side, food was low, and the trains were brought through the tunnel to Wellington, where they remained stranded for four more days. Within 24 hours of pulling through the tunnel to Wellington, a slide at Cascade Tunnel Station swept directly across the sections of track the trains had been occupying and wiped out the "beanery" where they had been taking their meals, killing two. After four more days of record snowfall, followed by heavy rains, the super heavy snow brought thousands of tons of white death down upon the trains, resulting in nearly 100 lives lost.

Railroads were the biggest thing going in North America in 1910, employing an estimated one-twelfth of the adult male population. Trains were transforming the nation, expanding the economy, unifying the populace, creating new states, and fueling the belief that anything was possible. Whatever setback it meant to GN, the Wellington avalanche could not slow the seemingly inevitable march of progress. The railroad was the lifeline to nearly a dozen communities between Index and Wellington. Weekend excursion trains brought tourists, campers, fishermen, hikers, hunters, and berry pickers.

The automobile was also making its way up the valley, and with it came new business opportunities and the call for better roads. Timber production and sawmills were on the rise, and when wartime copper prices went from 18¢ in 1915 to 44¢ in 1916, Sunset Mine resumed production after being dormant for a decade.

There was talk of an 8-mile tunnel or perhaps a 17-mile tunnel, but as it became clear the United States would enter World War I, all that went on hold. The massive timber production capacity of the valley would be consumed while meeting the government's wartime demand for lumber, with special trains being put on to carry shipbuilding materials and other lumber east.

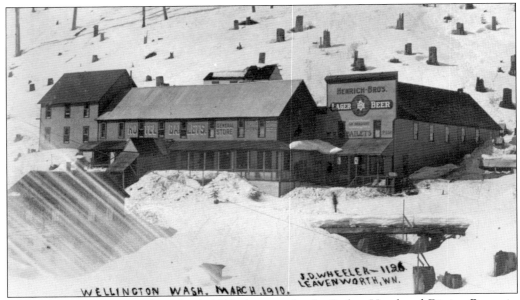

AFTER THE DISASTER. In this March 1910 photograph, the Bailets Hotel and Dining Room in Wellington looks peaceful only days after the greatest avalanche disaster in American history took place less than 100 yards west. Two westbound trains, the *Seattle Express* and the *Fast Mail*, had been snowbound nearly a week when a mass of deep, rain-laden snow cascaded down, crushing everything it its path. The King County coroner's office recorded 96 deaths.

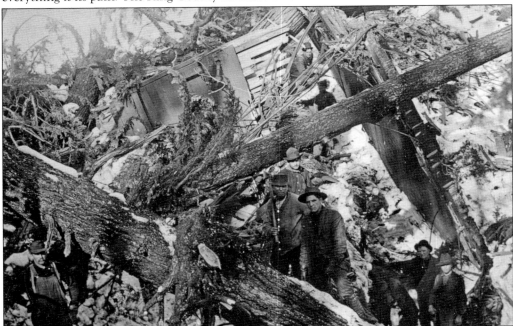

DIGGING FOR SURVIVORS . . . AND BODIES. The mostly wooden railcars were crushed into kindling by the force of the avalanche, and rescue efforts were hampered by vast amounts of packed snow and debris. Of the 160 people estimated to be in the Wellington area, nearly 100 perished, roughly one-third passengers and two-thirds railroad employees. Another 30 were injured. It would be more than a week before all the bodies were located.

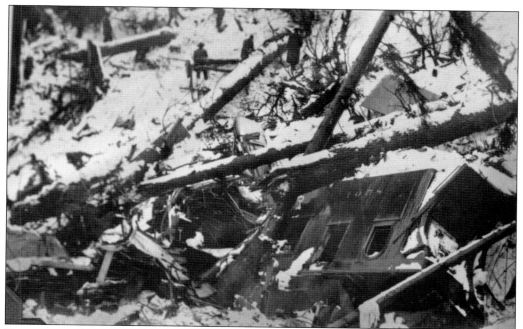

REDUCED TO SPLINTERS. Railcars were "crushed like an elephant stepping on cigar boxes," to paraphrase a quote in novelist Gary Krist's brilliant book *The White Cascade*, where he captured both the facts and the fabric of the tragedy and weaved it into a marvelous, horrendous story. The last survivor was found several days later; and some laborers' bodies were never identified.

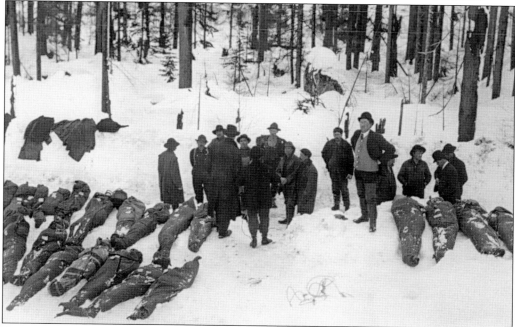

BODIES RECOVERED AND READY FOR REMOVAL. The slide came during the night, so most passengers and many rail employees were in sleeping attire, thus carrying no identification papers. Identification was further complicated by the fact that many were crushed or otherwise disfigured. (Courtesy of MOHAI.)

Wedding Day. Sidney Dennis Herbert Jones and Hester Dors are pictured here on their wedding day of May 29, 1906. Sidney was born in England, fought in the Boer War in South Africa, and, by December 1909, was an unemployed father of three in Skykomish happy to find work as a brakeman for Great Northern. He died at Wellington. Family lore says Hester, who would later marry William Timpe, received $250 in compensation. Industrial deaths were common; the money perhaps seemed fair.

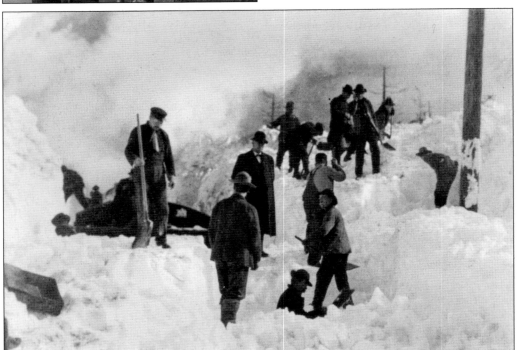

Great Northern Railway Problems. The arched dark form at center left is the top of a rotary snowplow. The boxes at left are filled with dynamite. With packed ice and snow blocking the route, crews used powder charges to blast snow from the tracks. It took 11 days before a train reached Wellington and 14 days before regular rail service resumed.

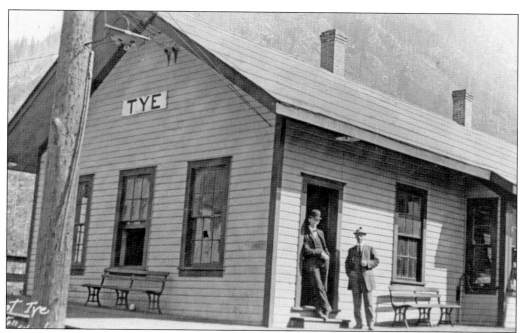

A Whole New Place. In October 1910, the Great Northern Railway renamed its Wellington station "Tye" as part of an effort to reassure travelers that the horrors of the Wellington avalanche could not happen again. The U.S. Census in the summer of 1910 listed 139 residents, more than 90 of whom were immigrants, predominantly laborers. The two largest nationalities were 29 Turks and 20 Greeks, traditionally not groups who have much affection for one another.

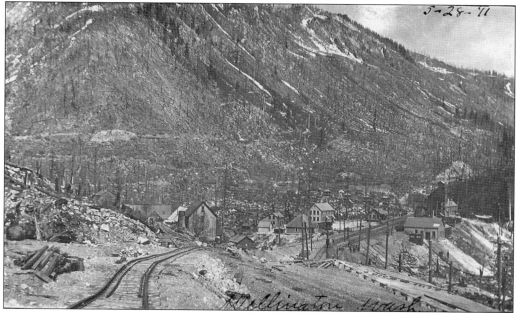

Postcard from "Wellington," Mailed on June 2, 1911. The card reads, "This is a view of our town taken last Saturday. You can see the snow is all gone but a little on the top. The boys find all kinds of flowers. Some I have not seen since we left Dakota. Blanche." While Great Northern had changed the name of its Wellington station to Tye, the post office name change came later.

Lee Pickett. No one is more responsible for the images in this book than photographer Lee Pickett, or Picket, as he often spelled it before 1920. He worked out of Index nearly 40 years, documenting events in the valley. At times, one has the sense if Pickett did not photograph it, then it did not happen. His wife, Dorothy Foster Pickett, donated his negatives to the University of Washington, and most are now searchable online there. (Courtesy of Pickett Museum.)

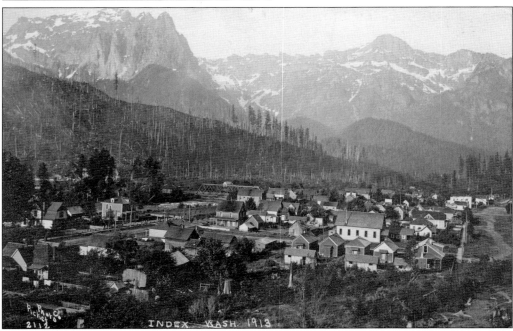

Prosperous Times. In the shadow of West Index Mountain, as it was called at the time, and Mount Persis to its right, Index continued to prosper, despite mining in the region not living up to its early promise. A movie theater opened in 1910, and the first car arrived in 1911. The town's only church, serving different Protestant denominations at various times, is the large white building at center right.

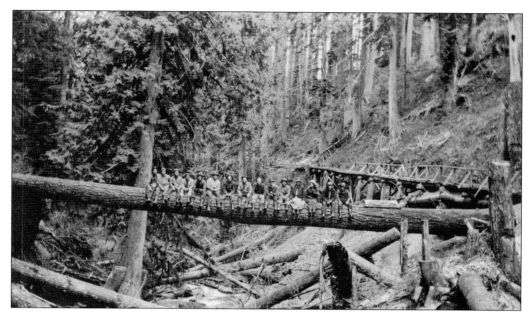

UNIVERSITY OF WASHINGTON MINING STUDENTS VISIT ETHEL MINE, 1911. Although the Ethel had impressive ore deposits and serious sums were invested, according to *Discovering Washington's Historic Mines*, the ore was complex to process and the developer and promoter was not a mining engineer. When things began going bad, he reportedly sold his holdings and resigned from the company, leaving the East Coast stockholders high and dry. (Courtesy of UWLSC, UW20307.)

TRAMLINE DOWN TROUT CREEK FROM SUNSET MINE. Accounts say a series of three trams moved ore to Index or some say connected with a logging railroad. In any case, the mine was idle most of the decade until World War I tripled the price of copper. By then, sections of tram had washed out, and the Sunset missed most of the high-price war years, closing again in 1920. (Photograph by Darius Kensey; courtesy of Whatcom Museum, 1978.84.1884.)

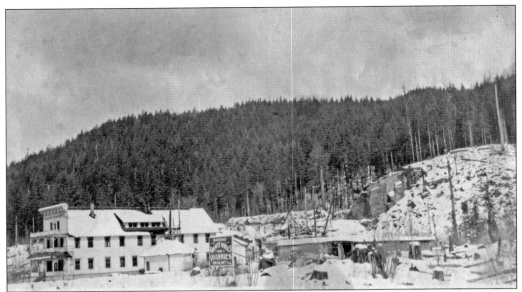

At Baring Wash, c. 1912. Important as John Maloney was in the early days of Skykomish, his footprint in Baring was likewise significant. He operated a hotel, a granite quarry, and a pack train business and had an interest in a shingle mill. In those days, the term "hotel" also could mean boardinghouse, and perhaps the main clientele of the Baring Hotel were crew from the quarry and the shingle mill.

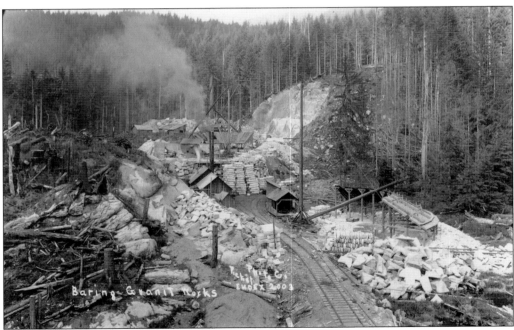

Baring Granite Quarry. As cities in the Northwest grew and expanded, granite was a major component of large building foundations and street curbing, and granite quarries flourished throughout the valley. John Maloney is said to have invested in quarries in eastern Washington as well and lost a lot when the Great Depression and the arrival of cement as a building material ended the use of granite. (Courtesy of UWLSC, Pickett 2003.)

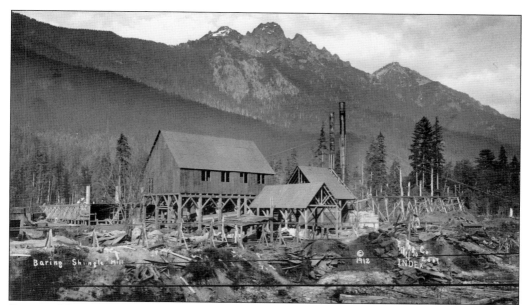

SHINGLE MILL AT BARING. Shingle or shake mills operated up and down the valley, with ready access to old-growth cedar and a railroad to carry the product to where cities and towns continued to grow. Wood houses with shingle roofs, heated by wood fires and lit by oil lamps and candles, readily burned, adding to the active market for more shingles and shakes. (Courtesy of UWLSC, Pickett 2007.)

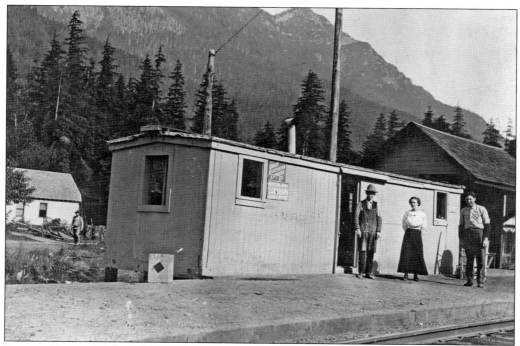

BARING DEPOT. William Timpe (in apron) and Mr. and Mrs. Engle are pictured here. Baring was little more than a flag stop on the Great Northern line with a converted boxcar serving as the depot, but the railroad was the lifeline to the world. The signs say Great Northern Express Company and Western Union Telegraph and Cable Office.

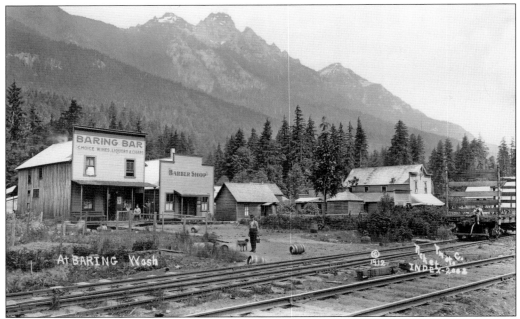

BARING, A PEDESTRIAN SOCIETY. In this 1912 photograph, there is no provision for a wheeled vehicle, horse-drawn or otherwise, to cross the tracks. Barrels lying about often appear in photographs from this era. Being handmade from wood and steel, they must have had considerable value, but they seem unlikely to be stolen, not being an item one could board a train carrying. (Courtesy of UWLSC, Pickett 2002.)

FOOTBRIDGE AT BARING. Bridges such as this were built at several places along both forks of the river, allowing people to live on both sides so long as they were willing to carry everything they needed from the shops and railroad depot. Horses could possibly have used this bridge but clearly not the bridge on page 23.

FIRST MACHINE TO REACH INDEX, APRIL 14, 1911.
A Hupmobile is parked here in front of the Bush
House Hotel. Hupmobiles were manufactured
from 1909 until 1940. Within a few weeks of
Hupmobile's accomplishment, the Flanders
Automobile Company dispatched a team driving
a Flanders 20 model to Index and beyond to
Galena, 8 miles east along the North Fork of the
Skykomish River, despite the lack of a real road.

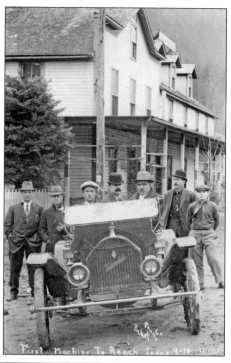

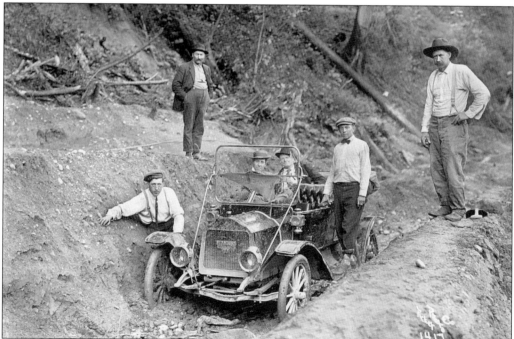

FLANDERS 20 MODEL "DRIVING" FROM INDEX TO GALENA. Accompanying the car were Everett
car dealer Bailey Hilton, Peter Flanders, James Pennington, D. I. Van Olinda, and Lee Pickett.
How long it took to traverse the 8 miles is not recorded. It can only be speculated what role this
"Sunday drive" with the gents in neckties shoveling mud had on the viability of Flanders cars.
They stopped being made in 1912. (Courtesy of UWLSC, Pickett 1417.)

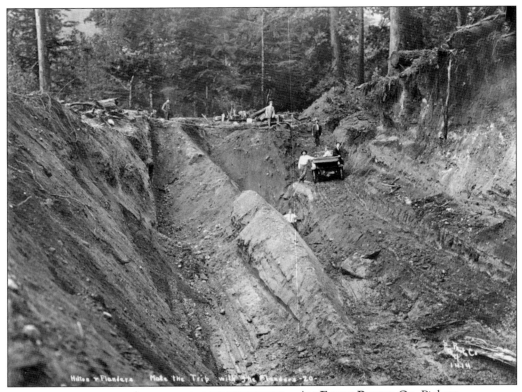

AN EARLY PHOTO OP. Pickett and Van Olinda were commercial photographers. It is not known if they were compensated or merely happy to be part of history on this perilous journey. Flanders ceased production in 1912, but the its parent, the U.S. Motor Company, made the profitable Maxwell line of cars until 1925, and the famously "tight" Jack Benny was still proudly driving his and getting laughs about it on his 1950s radio show. (Courtesy of UWLSC, Pickett 1414.)

THE AUTOMOBILE COULD NOT BE STOPPED. U.S. auto sales in 1911 reached almost 200,000; in 1912, some 216,000 were built. The face of America and of Skykomish Valley was rapidly changing. Within a few years of the first automobile reaching Index, there were gas stations at Baring, Grotto, Berlin, and Skykomish. Millard Fillmore Smith of Berlin led the formation of a Good Roads Club, and King County agreed to fund work as far as Skykomish.

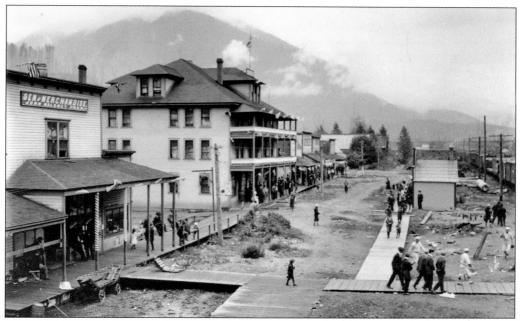

BALL GAME IN SKYKOMISH, C. 1912. On a Sunday or perhaps a Fourth of July, flags are flying, buildings are festooned, and ballplayers in both light and dark uniforms join the well-dressed men and families enjoying the day. Two players appear to be taking batting practice in front of the hotel. The automobile may be working its way up the valley, but there are still bushes and boardwalks on Railroad Avenue. (Courtesy of UWLSC, Pickett 1723.)

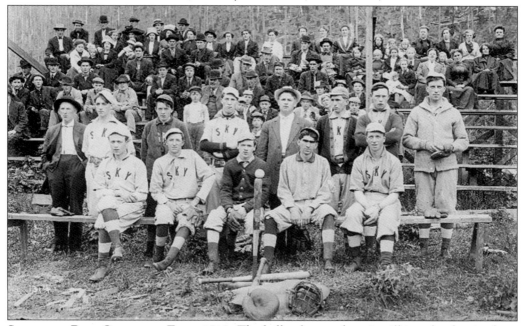

SKYKOMISH BALL CLUB WITH FANS, 1913. The ballpark was where it still is today, but in those days, access meant a pleasant walk over the logging railroad bridge east of town. People turned out weekly to picnic and enjoy the contest. Skykomish teams fared well in the years for which records exist, often winning the league.

SKYKOMISH HAPPENINGS

ED. BRADBURN WAS A SEATTLE VISITOR LAST WEEK.

MR. LAVIGNE HAS GONE TO THE SOUND IN QUEST OF A POSITION.

MISS EDITH SHANKS HAS GONE TO SEATTLE WHERE SHE HAS SECURED A POSITION.

MRS. FRED MYERS AND SON PAUL SPENT THE WEEK END AT EVERETT AND SEATTLE.

F. S. ELDER WAS HOME FROM ARLINGTON TO SPEND SUNDAY WITH HIS FAMILY HERE.

ANDREW PASCOE, JR. WAS HOME FROM BARING FOR A FEW DAYS TO HELP HIS PARENTS MOVE.

MISS EDITH FULLER WAS UP FROM SNOHOMISH OVER SUNDAY TO VISIT HER MOTHER AND GRANDPARENTS.

THE SKY BASKET BALL BOYS WILL GO TO MONROE THIS WEEK TO PLAY A MATCHED GAME WITH A TEAM AT THAT PLACE.

A. S. PASCOE AND FAMILY HAVE REMOVED FROM THEIR OWN HOUSE TO THE HOUSE RECENTLY VACATED BY MR. MITCHELL.

MRS. PAUL FOURNIER AND CHILDREN WERE MONROE VISITORS LAST WEEK. MR. FOURNIER SPENT SUNDAY WITH THEM AT MONROE.

WM. MERCEREAU WENT TO ARLINGTON THIS WEEK TO INSPECT THE SHINGLE MILL OF THE WATKINS SHINGLE CO., NEAR THAT PLACE.

FRED DUBUQUE AND FAMILY ARE EXPECTED TO ARRIVE HOME THE LAST OF THE WEEK. THEY HAVE BEEN FOR SEVERAL MONTHS AT PHOENIX, ARIZONA, FOR THE BENEFIT OF MR. DUBUQUE'S HEALTH.

A GAME OF BASKET BALL WAS PLAYED IN THE SKY HALL SATURDAY NIGHT BETWEEN A TEAM FROM SNOHOMISH AND THE SKY TEAM, RESULTING IN A VICTORY FOR THE SKY BOYS BY A SCORE OF 24 TO 8. IT WAS A GOOD GAME AND A LARGE CROWD OF SPECTATORS WAS PRESENT.

MR. AND MRS. W. F. ROHDE ENTERTAINED SIXTEEN GUESTS AT A VALENTINE PARTY AT THEIR HOME TUESDAY EVENING. A HEART HUNT AND VALENTINE CONTEST AFFORDED MUCH AMUSEMENT. THE WINNERS OF THE PRIZES IN THESE CONTESTS BEING G. H. CASHMAN, AND J. A. ROBINSON. DAINTY REFRESHMENTS WERE SERVED AND THE GUESTS DEPARTED NEAR MIDNIGHT, HAVING SPENT A DELIGHTFUL EVENING.

OTHER SIDE OF THE COCK FIGHT STORY

SKYKOMISH, WASH., FEB. 13, 1911 EDITOR INDEX NEWS

WILL YOU KINDLY GIVE SPACE FOR AN ANSWER TO AN ARTICLE PUBLISHED IN YOUR ISSUE OF FEBRUARY 2nd, SIGNED BY JAS. BALKWELL, IN WHICH HE ATTEMPTS TO DEFAME SOME OF OUR VERY BEST CITIZENS, MEM WHO EARN THEIR LIVELIHOOD FOR THEMSELVES AND THEIR FAMILIES BY STEADY, HARD AND HONEST TOIL, MEN OF STERLING QUALITIES AND WHO ARE A CREDIT TO ANY COMMUNITY.

THE FACTS OF THE TROUBLE ARE AS FOLLOWS:

MR. BALKWELL, HAVING BEEN DRIVEN OUT OF MANY PLACES WHERE HE PLIED HIS NEFARIOUS BUSINESS, SETTLED UPON SKYKOMISH AS A SAFE PLACE FOR COCK FIGHTS, WHERE BY CHARGING ADMISSION AND BETTING, HE COULD ACCUMULATE MONEY. SEVERAL FIGHTS HAD TAKEN PLACE HERE, FIRST IN THE TOWN HALL, THE LAST TWO FIGHTS IN A HOUSE ESPECIALLY BUILT FOR THAT PURPOSE AND SITUATED NEAR THE CENTER OF THE VILLAGE AND LESS THAN 200 FEET FROM THE MAIN STREET. THE COCK FIGHTS WERE INVARIABLE HELD ON SUNDAYS AND LASTED ALL DAY.

MR. A. J. POLLOCK, ONE OF THE TOWN COUNCIL, NOTIFIED SOME OF THE PARTIES TO STOP THE FIGHTING, BUT THEY DEFIED HIM. IT WAS AT HIS REQUEST THAT F. S. ELDER, JAS. MORGAN, GEO. H. CASHMAN AND JAS. B. WATKINS WERE SWORN IN AS OFFICERS ON SUNDAY MORNING, JAN. 1st. THE OFFICERS, ACCOMPANIED BY MAYOR JOHN MALONEY AND COUNCILMAN A. J. POLLOCK, WENT TO THE HOUSE WHERE THE FIGHT WAS THEN IN PROGRESS AND ARRESTED FORTY-TWO MEN. THEY FOUND IN THE BUILDING SEVERAL DEAD COCKS PILED IN ONE CORNER, A NUMBER OF CANVAS BOXES CONTAINING GAME COCKS READY FOR THE FRAY WHEN THEIR TURN CAME TO FIGHT TO DEATH WITH THE SHARP STEEL SPURS WITH WHICH THE SPORTS ADORN THEM. MORE MEN ARRIVED LATER IN THE DAY ON THE NOON TRAIN WITH ANOTHER LOT OF GAME COCKS, WHICH INDICATES THAT THEY HAD PLANNED TO CONTINUE THE FIGHT ALL DAY. WHEN THE FIGHT WAS STOPPED, IN THE PIT IN THE CENTER OF THE BUILDING THERE WERE TWO MEN, EACH CHAMPIONING A COCK, ONE OF WHICH WAS IN A DYING CONDITION FROM THE WOUNDS WHICH IT HAD RECEIVED. THERE WAS BLOOD IN THE PIT, ON THE FLOOR AND ON THE GROUND IN FRONT OF THE BUILDING. A NICE SPECTACLE ON SUNDAY IN A SMALL VILLAGE OF LESS THAN THREE HUNDRED INHABITANTS, OVER SIXTY-FIVE OF WHICH ARE CHILDREN OF SCHOOL AGE.

THE MEN ARRESTED WERE INFORMED THAT MR. MURPHY, THE NEW PROSECUTING ATTORNEY OF KING COUNTY, WOULD BE NOTIFIED OF THE ARREST AND HIS ADVICE ACTED UPON. MANY OF THE PRISONERS WERE STRANGERS AND PLEADED TO BE FINED AND LET GO AT ONCE, PROMISING THAT THEY WOULD NOT AGAIN ATTEMPT TO TAKE PART IN A CHICKEN FIGHT AT SKYKOMISH, SOME OF THEM CLAIMING THAT IT WAS THE FIRST CHICKEN FIGHT THEY HAD EVER WITNESSED. NOT HAVING ANY PLACE TO HOLD THE PRISONERS THE JUSTICE OF THE PEACE WAS SENT FOR AND EACH WAS FINED TWO DOLLARS AND FORTY-FIVE CENTS BEING COLLECTED, SOME OF THE SPORTS CLAIMING THAT THEY HAD NO FUNDS WERE TURNED LOOSE WITH THE ONES WHO PAID. ALL THE MONEY WAS TURNED OVER TO THE TOWN TREASURER.

THE OFFICERS WHO MAD THE ARREST AND THE JUSTICE OF THE PEACE DID NOT RECEIVE, NOR WILL THEY ACCEPT, ANY PAY FOR THEIR SERVICES; THEY HAD A BETTER MOTIVE, TO STOP COCK FIGHTING IN SKYKOMISH.

MR. BALKWELL WAS NOT IMBUED WITH THE SPIRIT OF THE BIRDS WHICH HE DELIGHTS IN SEEING SLASHED TO DEATH. WHILE UNDER ARREST HE SPENT A GOOD PORTION OF THE TIME CRYING, TO THE PEOPLE WHO KNOW MR. BALKWELL OR HIS REPUTATION, A REPLY TO HIS PUBLISHED STATEMENT WOULD BE UNNECESSARY.

THE ABOUVE ARE THE FACTS AS I SAW THEM ON SUNDAY MORNING, JANUARY 1st.

JOHN MALONEY

OTHER SIDE OF THE COCKFIGHT STORY. At least briefly, baseball was not the only spectator sport available to the good citizens of Skykomish in the decade. This account by Mayor John Maloney "setting straight" an earlier account said to "defame some of our very best citizens . . . men of sterling qualities and who are a credit to any community" appeared in the "Skykomish Happenings" section of the *Index News*.

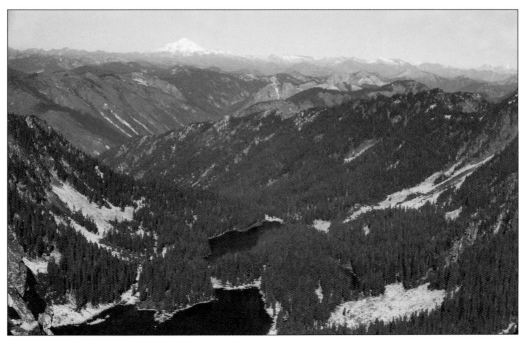

MOUNT BAKER IN THE DISTANCE. More common forms of recreation in the valley involved hiking, fishing, hunting, and berry picking in the vast and beautiful high country. Besides locals, weekend recreation trains came from Seattle and elsewhere to give urbanites an opportunity to enjoy the valley's bounty.

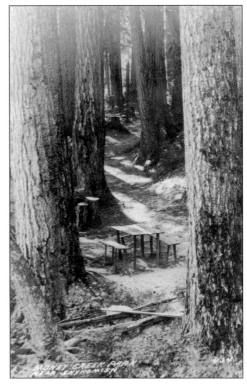

MONEY CREEK PARK. As people came, the U.S. Forest Service recognized a need for camping sites and marked trails both to protect the people and the wilderness.

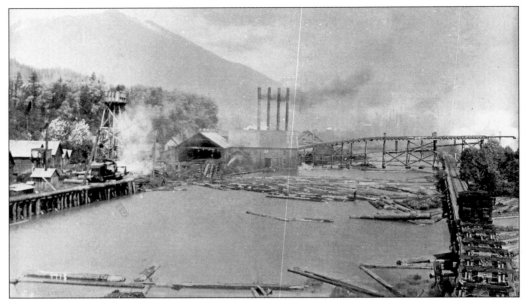

Skykomish Lumber Company Mill at Milltown. The empty logging train at right indicates that it has just dumped a load of logs into the millpond and is headed back to the woods. Acquired in 1917 by the Bloedel Donovan Lumber Mills, with the exception of a five-year span in the early 1930s, it operated continuously until 1945, when it was sold. It continued to operate on a lesser scale nearly 10 more years.

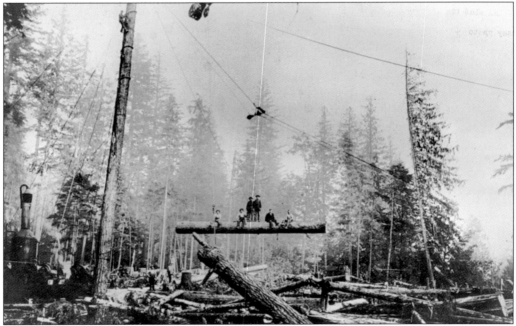

High Lead Logging. When flat ground, "easy" trees near rivers were gone, logs needed to be yarded to central "landings" for loading onto railcars. Here a crew shows off for the camera by posing on a log hanging on the loading line while the angled log is being pulled to the landing from the woods. On the spar tree, a rigger poses. In normal logging operations, riggers mostly avoided "working" spar trees. (Courtesy of MOHAI.)

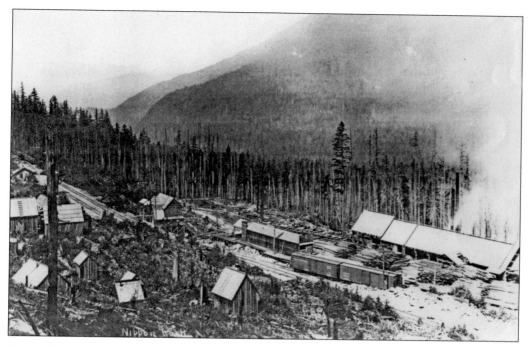

NIPPON LUMBER COMPANY AT ALPINE. The Chinese Exclusion Act of 1882 meant no Chinese could be imported for railroad work, but Japanese workers came, and the story goes that they lived at Nippon. The name was changed to Alpine in 1914. Production at the mill at Nippon/Alpine rose steadily throughout the decade, peaking during the war years at roughly 600 railcars annually. The Clemans brothers owned and operated the mill and had a reputation for being good employers, offering free rent, easy credit at the company store, and free wood for heating. The men in the photograph below are likely carrying mill ends for firewood as they go home for lunch.

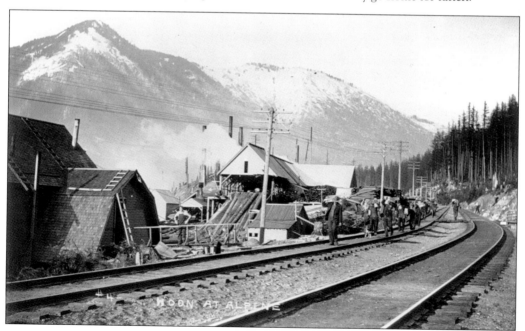

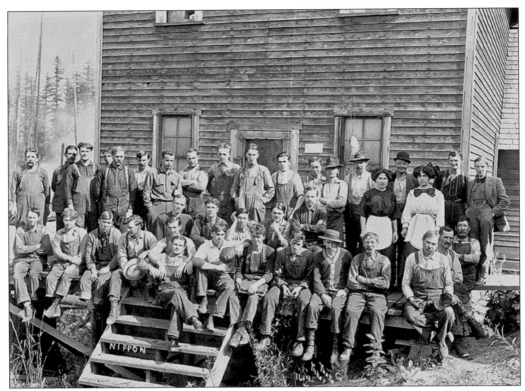

Two Mill Crews. The crew at Nippon, above, in 1912 consisted of essentially Caucasian workers. The photograph below is a crew from a Skykomish mill about 1917, where a significant percentage of the people are Japanese. Chet Miller, fifth row left, appears for years as a regular in photographs of Sky baseball teams (see page 65) and later as a school board member, a Mason, and with other civic activities.

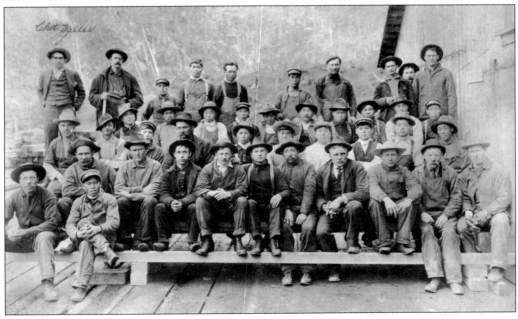

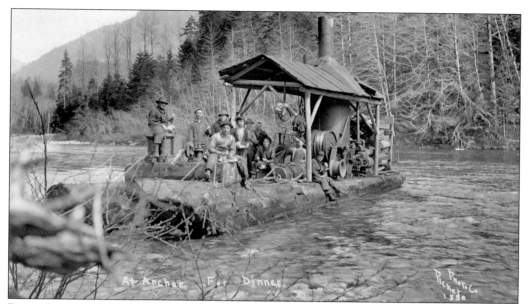

RIVER CROSSING. A steam donkey and crew have lunch before crossing the Sky. Below, "Her Last Swim" is what photographer Lee Picket called this river crossing. The archives do not document what happened next. In its working mode, a yarder (donkey) is attached to a large stump "tail-hold," so when lines are run out into the woods, logs can be pulled to the landing. Donkeys are moved by running the mainline through the fairlead at the front, to keep the line spooling evenly on the drum, and then out to a stump in the direction the donkey needs to travel. Then the donkey winches itself along the ground (or across the river) toward the stump and its final destination at a slow, labor-intensive, and occasionally unpredictable pace. (Both, courtesy of UWLSC; above Pickett 1550, below Pickett 1553.)

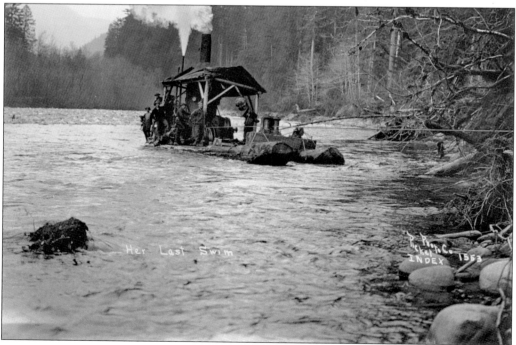

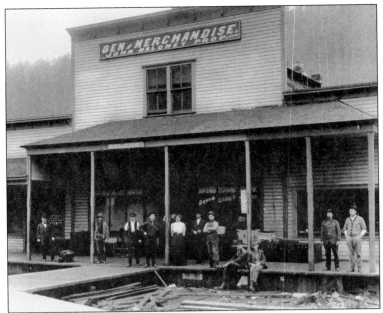

MALONEY'S STORE, c. 1915. Maloney's has been a Skykomish institution for eight decades. The couple in the center is Louisa and John Maloney; next to John with arms folded is Henry Timpe. The man in the vest is William Timpe, and the kid with shiny knees is Bill Mercereau. The others are unidentified. The photograph is from about 1915, before the automobile caused the removal of street-crossing boardwalks.

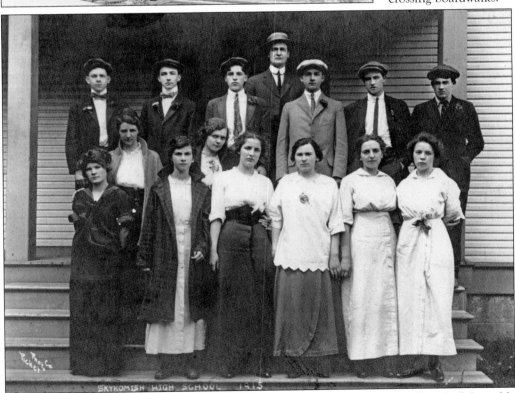

SKYKOMISH HIGH SCHOOL, 1915. From left to right are (first row) two unidentified (possibly teachers), Genevieve Maloney, Alice Langland, Eva Elder, Helen Bartlett, Sadie Cooper, and Viola Pascoe; (second row) Johnny Maloney, Clyde Thompson, Dick Pascoe, Professor Hanks (behind), Archie Turnbull, Sam Turnbull, and Charlie McEvoy. It is not known if owning a soft cap was a graduation requirement for boys.

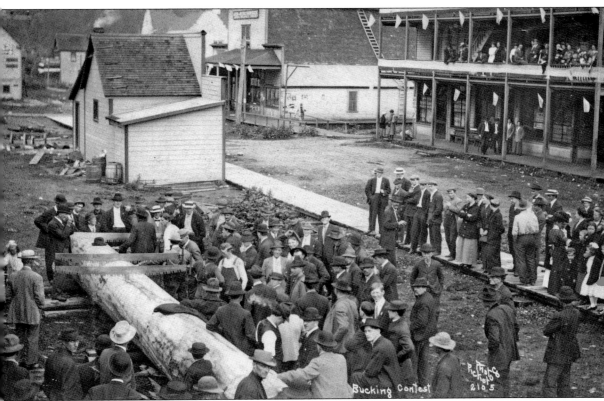

Bucking Contest

GET YOUR HAT. There must have been horses around, but essentially, Skykomish was pedestrians only, as evidenced by the boardwalks during this log bucking contest, possibly a Fourth of July event, about 1915. Only four men are hatless, and two of them are contestants. In a place that rains more than 100 inches a year spread across 200 days, a hat is a necessity for a pedestrian. The odd little shop at center left belonged to Andy Hove. An advertisement in the 1921 Skykomish school yearbook said he could fix anything, "Automobiles, Plumbing, Shoes, Etc."

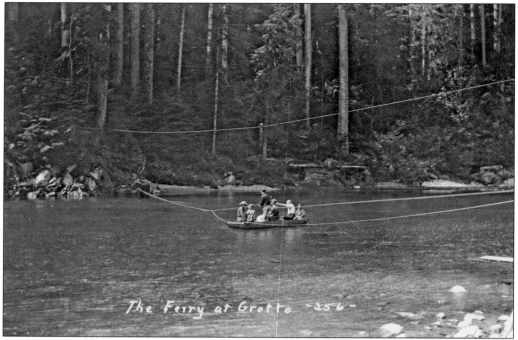

THE FERRY AT GROTTO. Before the bridge at Money Creek, people from Grotto or elsewhere "down valley" wishing to visit Money Creek Park or elsewhere south of the river had the option to cross the Skykomish River via this ferry.

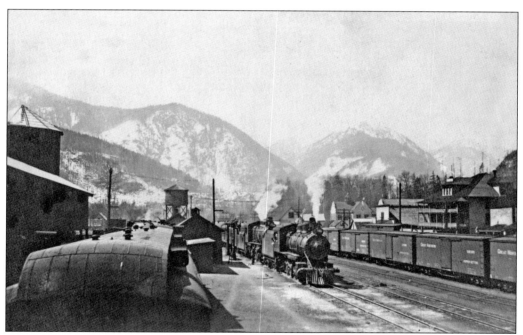

THE RAIL YARD IN SKYKOMISH. This was an active place from the time Great Northern completed its transcontinental route in 1893 and remained particularly busy during World War I as lumber from the valley and other raw materials moved east and west in support of the war effort.

Four

1920–1930

The Roaring Twenties truly roared into the valley. The Great War, which kept lumber mills in the valley working at capacity throughout, had ended successfully for United States, and the sky seemed the limit. Wealth may not have been evenly distributed, but there was work for nearly everyone, and the idea persisted that even greater things were yet to come. And greater things came.

The railroad replaced its roundhouse in Gold Bar by doubling the size of the roundhouse in Skykomish, and survey work began on the 8-mile tunnel at Scenic. In 1925, the Stevens Pass Scenic Highway officially opened. The Portland Cement Company built a large plant at Grotto in 1926, and mining operations continued above Money Creek, Miller River, and along the North Fork.

A major local prizefight between Jack Humphrey and Kid Kelly was held at Scenic. And daredevil Al Faussett drew a crowd said to number 3,500, not all of whom paid the $1 admission, to see him ride his canoe *Skykomish Queen* over Sunset Falls.

Skykomish had a doctor and a theater, and the school began publishing a newspaper and a yearbook for the first time. Articles from those publications about the need to make laws restricting cattle from town dairies wandering the streets (how does this make our town look to visitors?) and "before long we'll be needing a streetcar system" capture the attitude of the time.

Telephone communication meant the U.S. Forest Service could station lookouts on mountaintops to spot and announce forest fires as soon as they began.

The event, however, that would dominate economic life in the upper valley in the 1920s was the decision by Great Northern to bore the long-discussed 8-mile tunnel from Scenic to Berne, and with that came the decision to fully electrify the line from Skykomish to Wenatchee. Crews of men totaling nearly 3,000 worked three eight-hour shifts a day to build the tunnel in record time, and simultaneously the massive four-story "Substation" needed to convert AC grid power to DC to drive electric engines was built in Skykomish.

The 1920s did indeed "roar" in the upper valley.

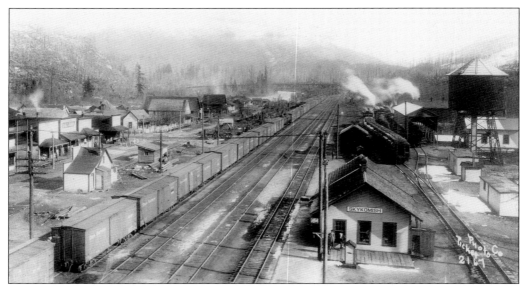

SKYKOMISH IN THE EARLY 1920S. The depot had not yet been moved across the tracks to make room for the "Transformer Building" needed to power the electric engines through the new tunnel. There were stumps all along Railroad Avenue between the businesses and the tracks. The logging bridge can be seen in the distance.

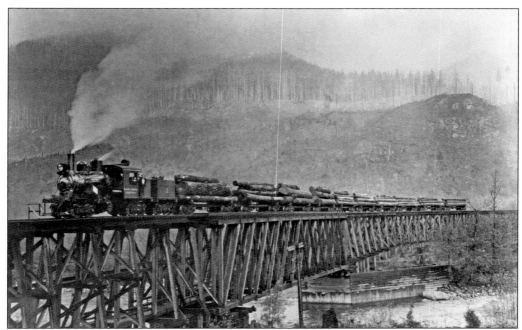

A CLASSIC DARIUS KINSEY PHOTOGRAPH. The Bloedel Donovan log train, on the bridge visible in the photograph above, is bringing logs from Beckler River to the mill in Milltown. Note the pedestrian walkway under the roadbed used by everyone to walk to the ballpark or the swimming hole up Beckler.

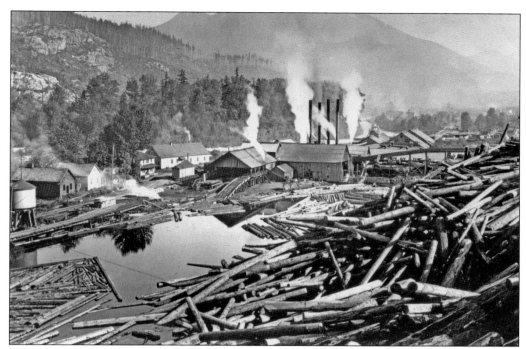

GEARING UP FOR WINTER. One account says the Bloedel Donovan Lumber Mill needed to cold deck 8-million board feet of timber in order to operate until spring after logging sites were snowed out in the fall.

HIGH LEAD LOGGING OPERATION. By hanging rigging in a spar tree and running a triangulated "circle" of line out into the woods, empty chokers are pulled to the logs by the haulback line and attached to logs; then the heavier mainline pulls the "choked" logs to the landing for loading.

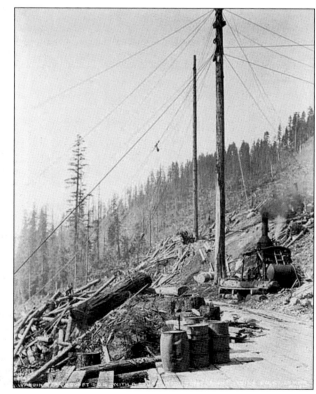

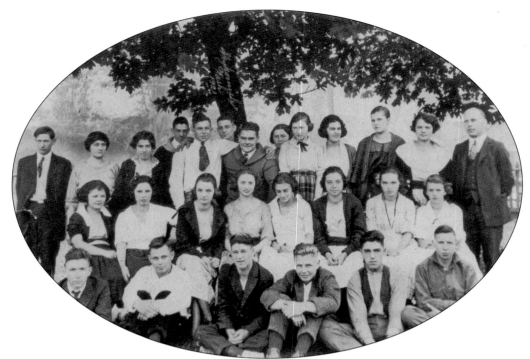

SKYKOMISH HIGH SCHOOL, 1921. Shown are (first row) unidentified, Paul Fournier, unidentified, Norm McCausland, Raleigh Maloney, and Francis Manning; (second row) Rennie Haven, Adele Manning, unidentified, Rose Manning, Mary Mossop, unidentified, Alice Mitchell, and Martha Mercereau; (third row) Henry Timpe, Olive Bowman (teacher), Margaret Armstrong (teacher), Edward Maloney, unidentified, Bill Hallanan, Gerald Smith, Florence Manning, Alice McEvoy, Geraldine Maloney, Alice Halverson, Marie Langland, and Supt. Charles Buddie.

THE MASONIC HALL OF LODGE 259. The Lodge was built in 1924 with volunteer labor on land donated by John Maloney, a strong Catholic who did not join the Masons, although his son John Jr. did years later. The building and the Lodge have played a pivotal role in the social fabric of Skykomish since the 1920s and remain active in community events today.

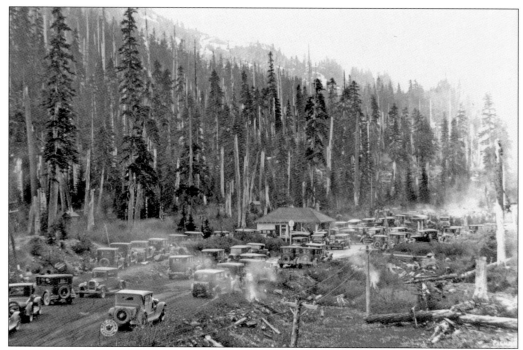

STEVENS PASS SCENIC HIGHWAY. On July 11, 1925, the highway officially opened with George Startup as the emcee and speeches by Gov. Roland Hartley and other dignitaries. Although the road was little more than a winding, narrow, dirt track, the opening celebration was attended by more than 1,000 people arriving at the summit in 283 vehicles. They were greeted by a service station and store built the previous year by Jake Beattiger.

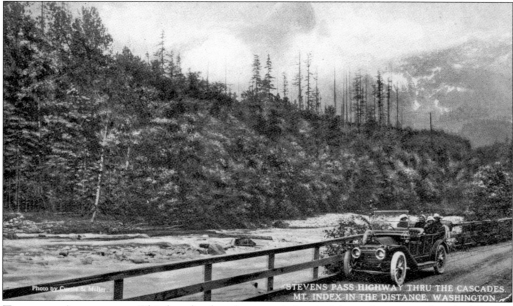

TRAVEL BY AUTOMOBILE. This hand-colored postcard sketch delivered intricate detail of the car but hardly did justice to Mount Index. The car was the "in" thing and was rapidly transforming the valley, as it did the rest of America.

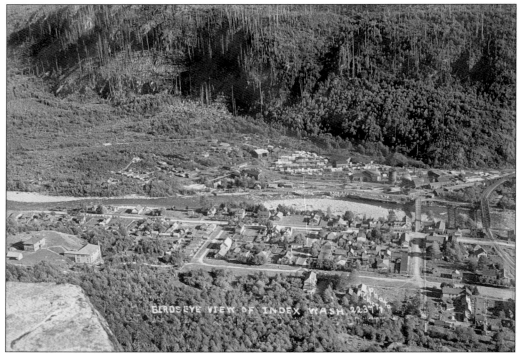

INDEX, C. 1925. The new car bridge is in place after the floods a few years earlier. The Index-Galena Logging Company mill across the river is in full production. Redman's Hall (at times called the Odd Fellows Hall) is above the "W" in Wash. The schools on School House Hill are at left. (Courtesy of UWLSC, Pickett 2237.)

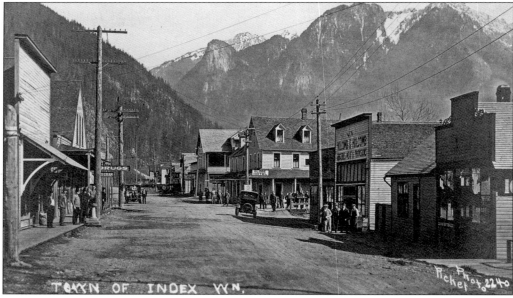

AVENUE A, INDEX, "MAIN STREET." The road over the bridge goes right, in front of the Globe Hotel (center), and there is a sign for a garage farther down. Holcomb and Holcomb "Groceries, Meats, & Provisions" is center right, next to the light pole. Jo Ann Roe's book *Stevens Pass* says seven mining companies maintained headquarters in Index in 1926.

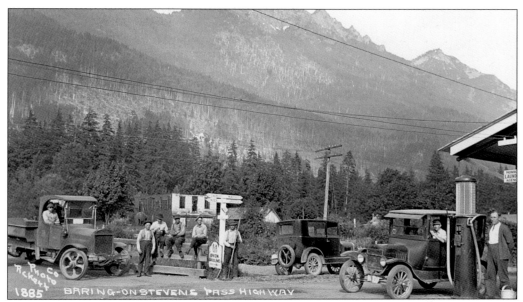

BARING ON STEVENS PASS HIGHWAY. This photograph was taken after the highway opened in 1926; the sign pointing east says "Wenatchee 97." Beyond the signpost is the shell of John Maloney's Grandview Hotel. The sign by the gas pump says "Monroe Laundry Agency," so people still sent laundry to Monroe. Pickett's signature Ford Model T with its forked-stick "Y" in the spare tire is also featured. (Courtesy of UWLSC, Pickett 1885.)

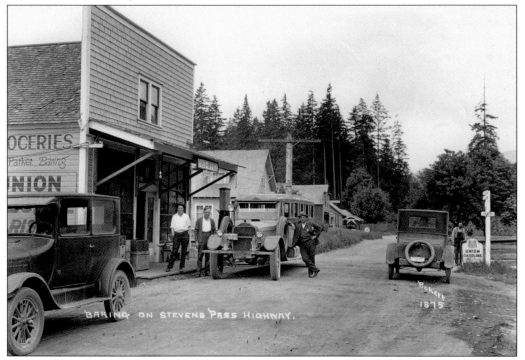

BARING POST OFFICE. In the mid-1920s, a new transportation option came into play. Referred to as "The Stage," people began taking the bus on trips "down below." Pickett's Ford Model T is at left. (Courtesy of UWLSC, Pickett 1875.)

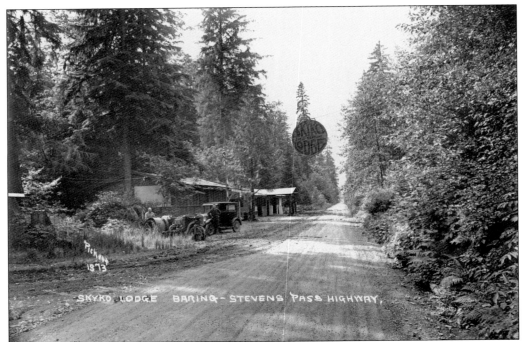

SKYKO LODGE AT BARING. One of the early "highway trade" way stations in the upper valley, the Skyko Lodge featured Shell gasoline and was established to provide lodging for people traveling by road. Records do not indicate how long it remained in business. The car is Pickett's Ford Model T. (Courtesy of UWLSC, Pickett 1723.)

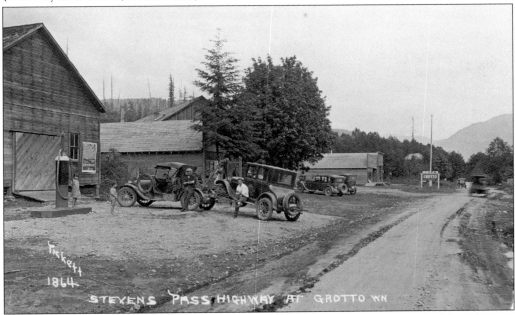

THE HIGHWAY BRINGS BUSINESS. Here is the garage and a wrecker with a wheel-less client at Grotto. Storefronts grew all along the new highway, providing services and goods for the traveling public. In 1926, there were at least six gas stations between Index and Stevens Pass; by 2000, there was one.

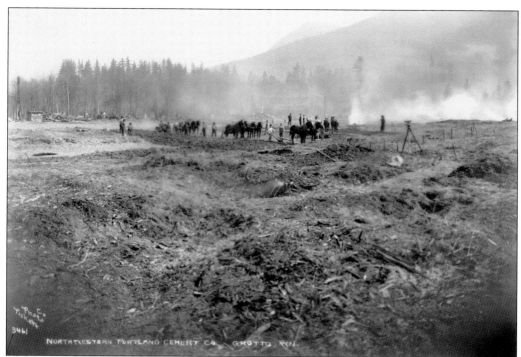

A NEW INDUSTRY. In 1926, ground was broken on 350 acres at Grotto to establish the Northwestern Portland Cement Company. With an abundance of limestone and clay in the hills nearby, as well as railroad and highway connections to bring materials and transport finished cement, the location was considered ideal. The plant operated successfully for three decades, employing upwards of 100 people throughout the period. (Both, courtesy of UWLSC; above Pickett 3461, below Pickett 4158.)

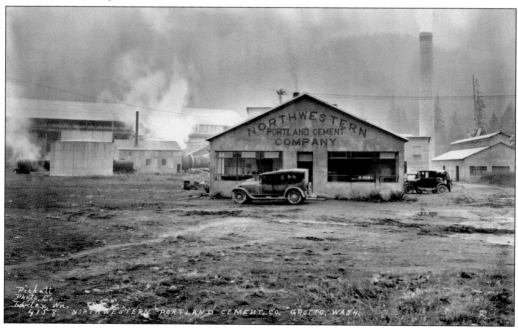

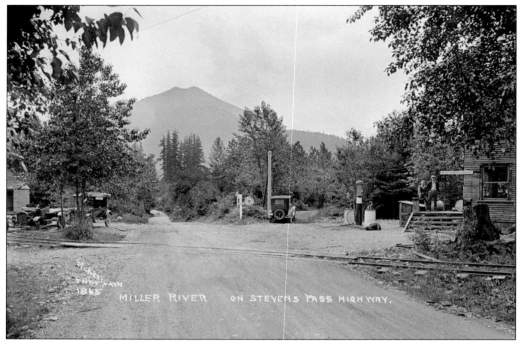

MILLER RIVER ON STEVENS PASS HIGHWAY. This image was part of the "Stevens Pass Highway" postcard series Pickett issued featuring his Ford Model-T Tudor sedan. The sign on the Red Crown gas station store reads "Mountain Honey For Sale." The mining spur narrow-gauge railroad track carried one small Apex mine ore car (pictured below) a day during much of the 1920s. (Courtesy of UWLSC, PIC1865.)

APEX MINE ORE CAR. Throughout the 1920s, W. J. Priestley operated the Apex. The white horse pulled the empty ore car 6 miles up to the cable tram station, where it was loaded with pre-sorted gold ore. The car then coasted back to Miller River. When a railroad car was filled, it went to the smelter in Tacoma. Helen Priestley is riding in the car. (Courtesy of Helen Priestley collection.)

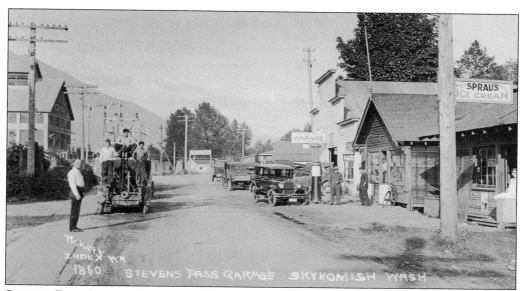

STEVENS PASS GARAGE, SKYKOMISH. The garage was operated by Jake Beattiger, and the large substation at left indicates this photograph was taken in 1928 or later. Sprau's Ice Cream from Monroe, a valley standard, is in front of the Sweet Shop. The vehicle at left is a wrecker.

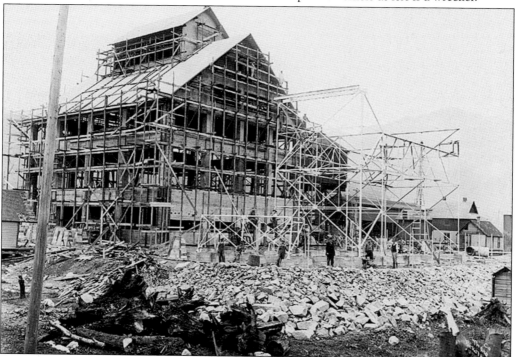

SKYKOMISH SUBSTATION UNDER CONSTRUCTION, 1927. Great Northern Railway's decision to build the 8-mile tunnel required electric power because the exhaust from steam engines in the tunnel would have been deadly. All trains between Skykomish and Wenatchee would be electrics. This "transformer building" converted Puget Sound Power and Light AC grid power to DC, and for the next 30 years, Sky remained a switching station for Great Northern. The finished building is on the left in the first photograph on this page.

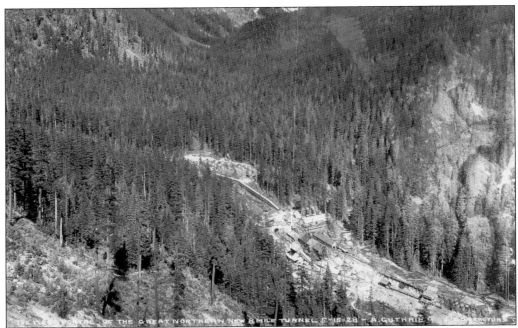

WEST PORTAL, 8-MILE TUNNEL. Once the decision to bore a tunnel was made, speed was of the essence because of deteriorating snow sheds. Contractor A. B. Guthrie Company set numerous records in completing this longest tunnel in the western hemisphere. To make such progress, 3,000 men worked 24 hours a day in three eight-hour shifts. Villages were built at both ends and above the middle, and crews worked numerous "faces" simultaneously. A smaller "pioneer" tunnel was dug parallel to the main line with a narrow-gauge mining rail system allowing equipment, power, and crews to move while work on the various faces continued. Replacement crews took over "on the fly" from those going off shift. The photograph above shows both the portal buildings and the crew camp. Below, a crew gets off work, dinner pails in hand. In the end, the tunnel replaced 9 miles of track, 1,000 feet of grade, and 1,941 degrees of curvature.

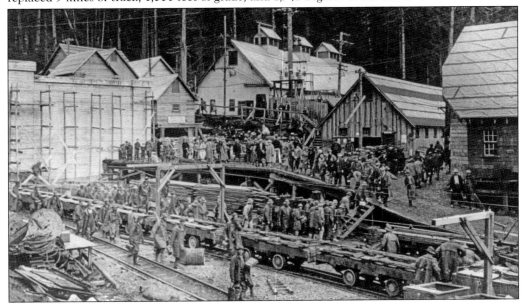

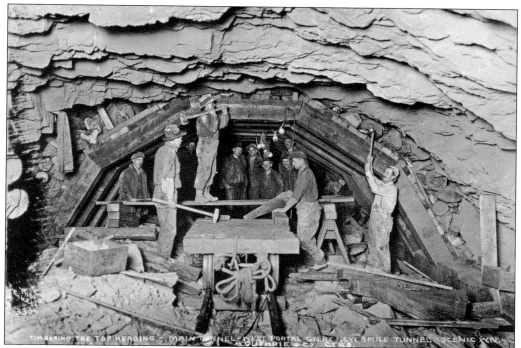

A Concrete Tube. While tunnel "borers" made and broke their own records for distance, numerous crews were right behind shoring up and preparing the hole for track and wiring for electrification. In addition to millions of board feet of timber cut, hewed, and hammered into place, GN records show 262,562 cubic yards of concrete were used to line the tunnel, enough to build a solid concrete building 100-by-100 feet and 60 stories high.

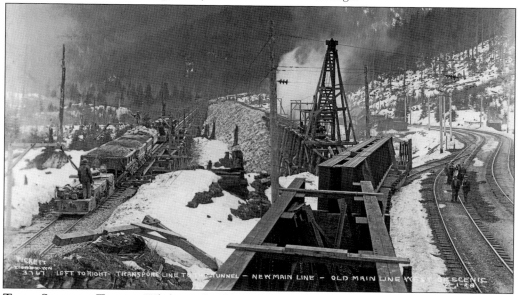

Three Separate Tracks. While regular GN traffic cruised by on the right and swung under the new main line (center) on its way east or west, contractors used the construction train (left) to transport materials to and from work sites. Selected riprap and other fill was hauled out of the tunnel on the "new" mainline to elevate the new rail bed.

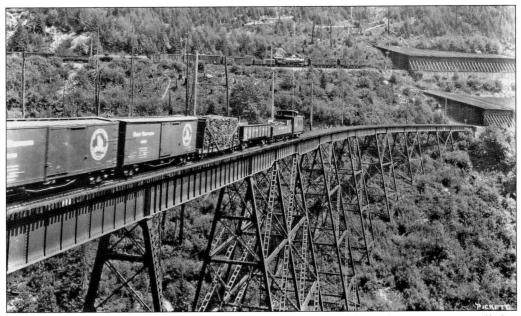

SINGLE TRAIN AT MARTIN CREEK TRESTLE. Both ends are visible as electric engines pull this "steam" freight through the horseshoe tunnel. The new Cascade Tunnel made all of this track, including 9 miles of deteriorating snow sheds, obsolete. Great Northern needed to be sure the entire "electrics" system was working and thoroughly tested before sending trains through the new tunnel.

SUNSET MINE IN 1929. Ultimately the largest producer of copper in Washington state, the Sunset had been mostly dormant after 1907 until World War I copper prices lured its owners back into production. Although too late to cash in on the high prices, the Sunset did operate successfully in the 1920s, producing more than 600,000 tons of ore per year from 1925 to 1929. (Courtesy of UWLSC, Pickett 4268.)

AL FAUSSETT AND THE *SKYKOMISH QUEEN*. In the 1920s, daredevils stood on wings of biplanes or went over falls across the country. Faussett, a logger from Monroe, rode this homemade canoe over Sunset Falls, starting his brief but historic career as a daredevil. A special train brought spectators, and a large area was cleared for parking, but ticket collection proved difficult as many of the reputed 3,500 crowd avoided paying. Faussett's name was spelled with only one T on the photograph above. (UWLSC, Pickett 3895.)

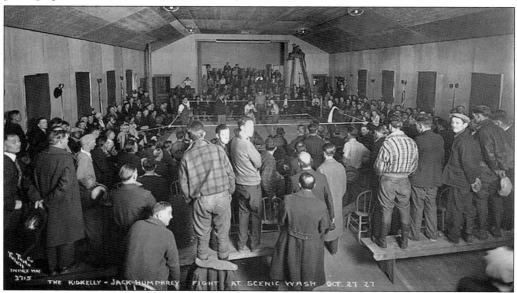

PRIZE FIGHT AT SCENIC IN 1927. Local favorite Kid Kelly took on the veteran Art Humphries (Pickett incorrectly labeled him "Jack") at the Scenic Recreation Hall. The *Everett Daily Herald* said Humphries put up a good defensive battle for two rounds until "Kelly broke through and a right and a left to the jaw finished his opponent in the fourth." In accounts of Humphries's career, Kelly is called "Battling Kelly" when talking about this fight.

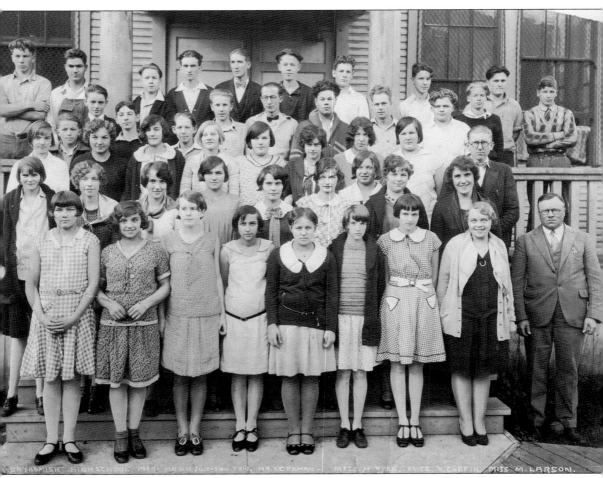

SKYKOMISH HIGH SCHOOL, 1929. From left to right are (first row) Katie Koch, Flora Miconi, Lysle McIntyre, Lanae Epps, Letha Eckert, Clara Hunt, Eleanor Valentine, M. Ryan (teacher), and Dan Johnston (principal); (second row) Katherine Plowman, Florence Timpe, Eileen Frasier, Mary Koch, Margaery Sawyer, Viola Timpe, Anne Rhodes, unidentified, and Ruth Coffin (teacher); (third row) Metta Jensen, Marian Howe, Gladys Handy, Dorothy Anderson, Kathleen Gauley, unidentified, Elizabeth Rhodes, Mary Hendriksen, and L. C. Eckman (teacher); (fourth row) George Valentine, Artie Henry, Bud Clary, Erwin Algar, Harry McCormick, Harold Lowman, Leslie Fowler, Kenny Pyatt, Bobby Edmonds, and Hank Timpe; (fifth row) Asa Smith, Matt Koch, Paul ?, Johnny Henry, Ralph James, Vern Hendricks, Orland Richardson, Clyde Webster, Lloyd Perry, and Earl Gibson. School enrollment peaked in the late 1920s at more than 260.

Five

1930–1940

The optimism and promise of the 1920s reversed quickly in the 1930s as the economic meltdown of the Great Depression struck nationwide. One additional direct cause of loss of employment locally was the completion of the Great Northern Railway's 8-mile tunnel, which was done in January 1929. Villages Corea, Embro (formerly Alvin), and Tye (formerly Wellington) existed to support the railroad, building and repairing snow sheds, maintaining track and water tanks, and switching from coal to electrics for the first Cascade Tunnel. When those 14 miles of railroad were abandoned, that employment went away with it.

Depression times closed the large Bloedel-Donovan mill in Milltown, a suburb just west of Skykomish, in 1931 for five years. The mill at Alpine closed forever.

The 1920s had been mining's most productive years since the start of the 20th century, but in the 1930s, mining died away, never again to be a source of significant employment. The Sunset Mine, 8 miles from Index and the largest producer of copper in Washington state, shipped roughly 600 tons of ore annually from 1925 through 1929, but as the national market for copper died away, the sun set forever on the Sunset as an active mine.

The railroad and U.S. Forest Service continued to employ in reduced numbers, but it was New Deal initiatives that ultimately offered work. The Works Progress Administration (WPA) and Civilian Conservation Corps (CCC) built the school and city hall in Skykomish, a ski lodge on the pass, fire lookouts and trails in the mountains, and expanded the Stevens Pass Highway, providing work for hundreds of otherwise unemployed valley residents as well as work for men from elsewhere who joined the CCC. The cement plant at Grotto operated throughout, but the predominant destination for its cement was the Grand Coulee Dam project, yet another New Deal initiative.

Stories abound of merchants advancing food "on credit" to out-of-work families, knowing "they'd pay when they could." Old-timers now who were children in the 1930s talk about everyone being poor so they did not take much notice that times were hard.

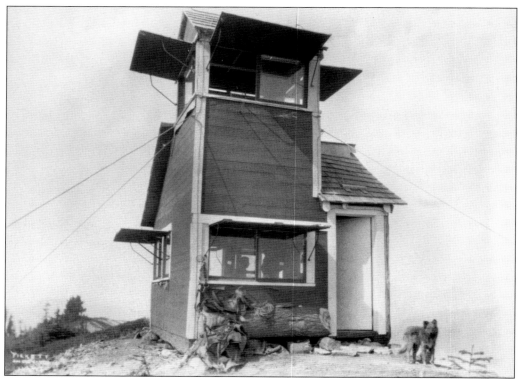

BENCHMARK LOOKOUT. Built in the summers of 1929 and 1930, Benchmark was at the end of a 25-mile walk north of Skykomish, although if one could hook a ride on the logging train or speeder, four hours' walking could be saved. Over the years, there were nearly a dozen fire lookouts covering parts of the valley, offering a lone lookout a life of solitude and the opportunity to experience unforgettable weather, both good and bad. Lightning storms are said to be particularly exciting when you are living in the tallest thing around.

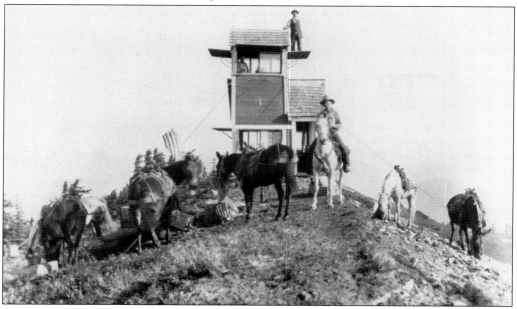

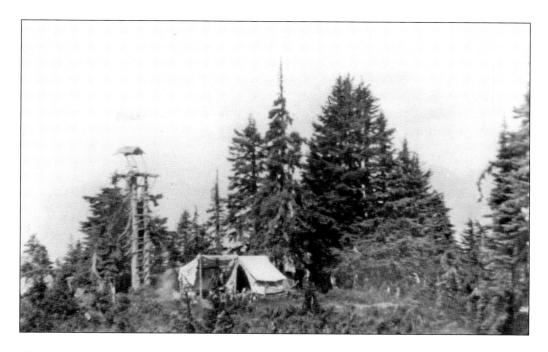

WATCHING FOR FIRE. The need for fire lookouts was recognized early on. As private timber was logged off and federal timberland came into play, additional lookouts were built. The first Beckler Peak lookout (pictured above) was a crude tower at the top of three standing trees. In the 1930s, the U.S. Forest Service and CCC labor built a tower around the old trees and replaced the tents with a cabin (pictured below).

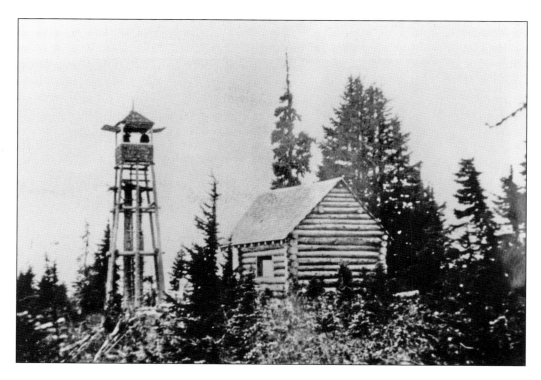

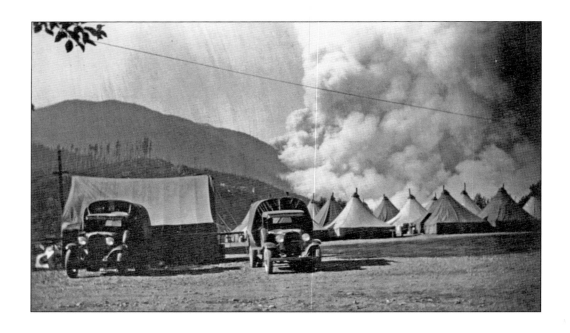

BECKLER RIVER FIRE. A massive fire up Beckler River burned 2,700 acres in 1933 and required a CCC crew of 600 working round-the-clock to control it. With mills and mines shut down and construction depressed throughout the decade, government projects funded by the WPA and built by CCC labor provided work for many who would otherwise have been unemployed.

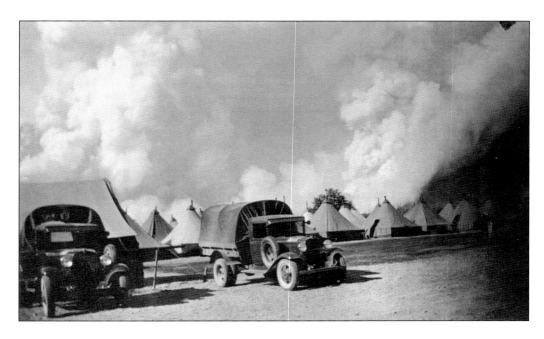

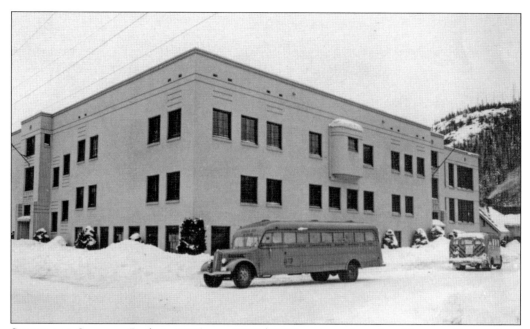

SKYKOMISH SCHOOL. Built in 1936 as a WPA/CCC project, the school has a self-contained gymnasium and lunch room with a kitchen, which is still in use.

SKYKOMISH TOWN HALL. It was built, or at least remodeled, as a WPA project, using lumber from the dismantled school. For years, the town hall housed the library, Skykomish having been the first community to contract with the King County Library for a branch location. A jail cell is in the basement. The library has since been relocated to a larger space across the tracks.

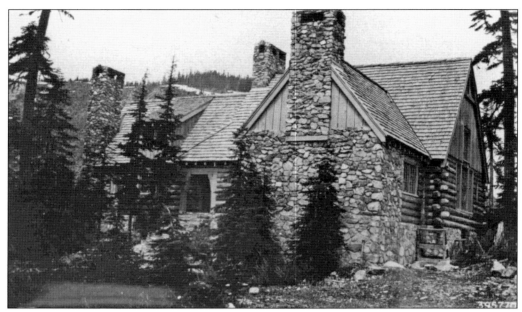

STEVENS PASS COMMUNITY BUILDING. Typical of many CCC projects, the "ski lodge" at Stevens Pass was built of local materials that could be "worked" into the desired outcome by the application of labor. The logs and shingles were cut and hewn locally, and the stones were gathered nearby as well.

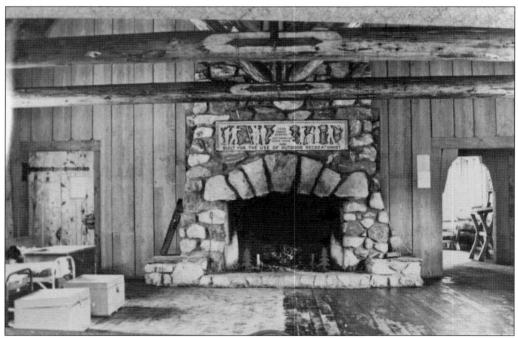

A HISTORIC FIREPLACE. The fireplace was said to have been designed by Leavenworth Ski Jumping legend Magnus Bakke; the sign above it reads, "Built For Use Of Outdoor Recreationist." Cross-country skiing at the Scenic Hot Springs Hotel and ski-jumping at Leavenworth came before, but the lodge, plus rope tows built by Bruce and Virginia Kehr, established Stevens Pass as a winter recreation destination.

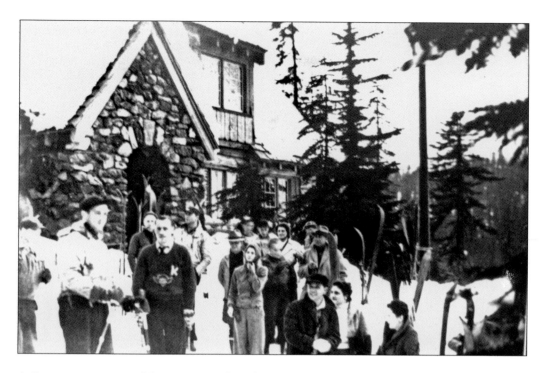

A RIDE THROUGH THE MOUNTAIN. Before the Stevens Pass Highway was kept open all winter, Westside skiers had to drive to Scenic and take a train through the tunnel to Berne, where an old school bus met and delivered them to the summit. In late afternoon, they would ski back to Scenic on the snow-closed road. By the end of the decade, Stevens Pass was kept open all winter, and more amenities were developed to support skiers, such as the rental cabin pictured below. The cabins had their "main entrance" on the second floor so they could be easily entered during deep snow lasting all winter.

GRANT VALENTINE WITH SNOWSHOES. As a junior at Skykomish High School, Grant, of Scenic, ran a trap line on Surprise Creek, catching several marten, mink, and a coyote, earning enough to buy his mother and his sister warm coats. The early chapters of his autobiography, *Country Bumpkin*, tell wonderful tales about life in that era and being a young man with paradise as your playground. (Courtesy of Grant Valentine.)

SELF-MADE RECREATION. Tony Rhodes (holding the oars) and three friends take a dugout canoe out for a cruise on Lake Elizabeth around 1935. (Courtesy of Della Rhodes.)

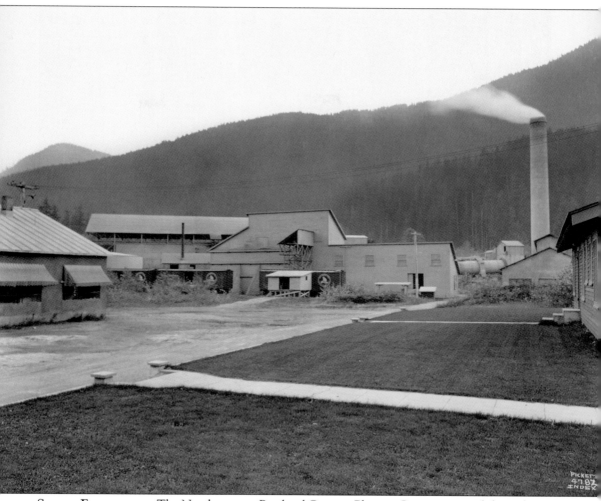

STEADY EMPLOYMENT. The Northwestern Portland Cement Plant at Grotto operated throughout the 1930s, thanks largely to the federally funded Columbia Basin Project. Construction on the Grand Coulee Dam began in 1933 and was not completed until 1942. At the time, it was the largest hydroelectric facility in the world and remains the largest concrete structure in the United States. It contained enough concrete to build a 4-inch-thick, 4-foot-wide sidewalk 50,000 miles long; that is the distance twice around the earth at the equator. The Grand Coulee Dam was a major customer of Grotto cement throughout the 1930s. (Courtesy of UWLSC, Pickett 3185.)

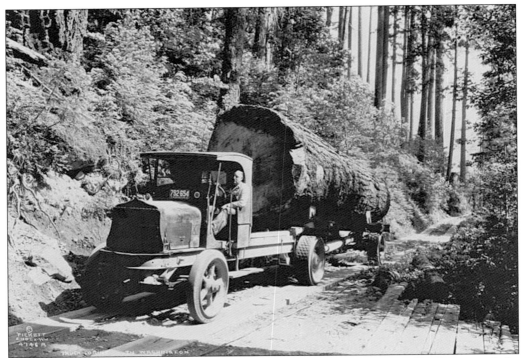

WOODS LOGGING COMPANY TRUCKS, 1931. These single-axle rigs near Miller River needed a boardwalk to deliver these massive logs to the mill in the hard rubber days (the time before logging truck tires had air in them). Like many other industries during the Great Depression, the mill closed later in 1931.

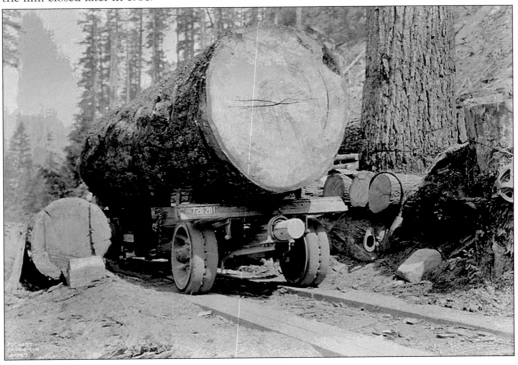

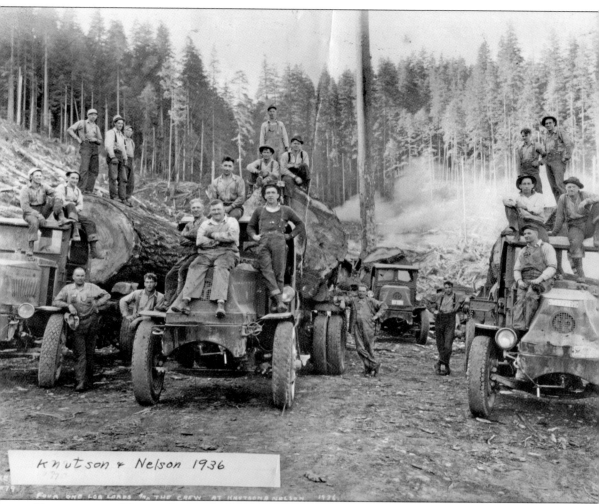

Knutson + Nelson 1936

FOUR ONE LOG LOADS AND THE CREW AT KNUTSONS NELSON 1936

KNUTSON AND NELSON LOGGING COMPANY AND FOUR ONE-LOG LOADS AT MILLER RIVER.
From left to right are (standing on log) Ed Knutson, partner; Harry Cough, head loader; and
Ray Casey, hook tender; (on cab) Chuck Riley and Aaron Green; (on ground) Art Nelson,
partner; (center truck) two unidentified; "Big" Bill Hendrickson; Ed Shermon (dark shirt); and
Ted Solomon (seated on cab); (seated on log) Henry Eshe and Milt Delaney; (standing) Wayne
Wilson; (leaning on bunk) Ed Bradburn; (right truck) Mel Hathaway; Carroll Handy; ? Morgan;
and Elbert "Buddy" Burdick; (standing on load) Ernie Dahlgren and Hank Savage. The tires on
these trucks were inflatable.

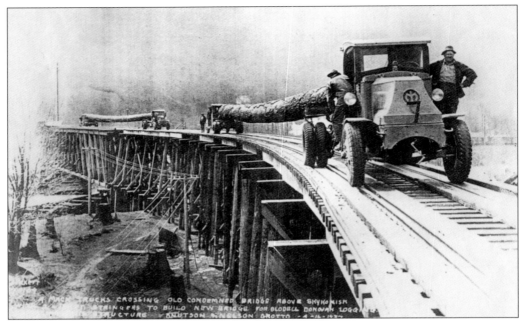

HAULING BRIDGE STRINGERS. In the mid-1930s, when the Bloedel Donovan mill reopened, some of the disused bridges were condemned, so huge fir stringers were hauled from the woods to build replacements. Above, trucks are crossing the railroad bridge east of Skykomish. For much of the decade, both logging trains and trucks shared use of this bridge. Below, trucks are negotiating the "S" curve on Milltown hill.

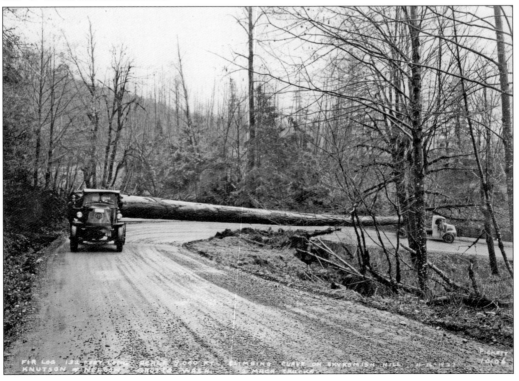

MASSIVE STOCKPILES. With the mill open, logging took off full bore. In the valley, snow usually closes the woods by November. The plan at the mill was to operate all winter, so 8 to 12 million board feet of timber needed to be cold decked, according to Earl Gibson, who also said sales of lumber were erratic in the 1930s. At one point, 1.5 million board feet of cut lumber was stacked all over the mill yard, needing a customer.

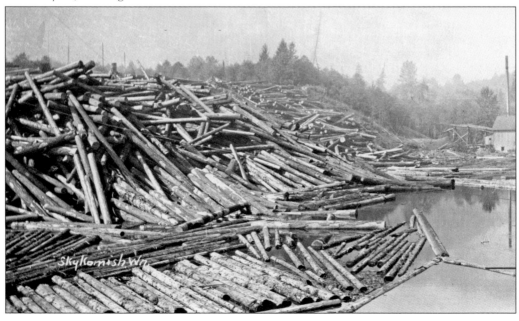

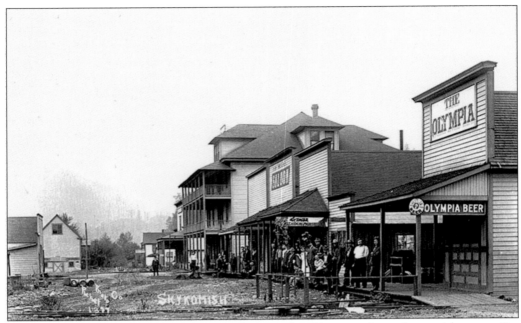

THE WHISTLING POST. In an earlier era, this was the Olympia, shown here with owner Pat McEvoy, wearing a white shirt out front. It operated throughout Prohibition as the Maple Leaf Confectioners, perhaps a reference to Canadian "products." When Prohibition ended, new owner Bryan Thompson renamed it the Whistling Post, a name that remains today. Until the 2008 oil-spill cleanup in Skykomish, it operated continuously for 104 years.

THE SHADOWS TAVERN. As Prohibition was ending, John Henry Jr. cleared land and built the Shadows Tavern along Stevens Pass Scenic Highway which at the time ran through Sky. The tavern was operated successfully until a new section of the highway opened across the river and trade fell off. The bridge to the new section of highway was, ironically, dedicated to John Jr.'s father John "Glick" Henry in early 1939. The tavern closed in late 1939. The building is a "recreation property" residence today.

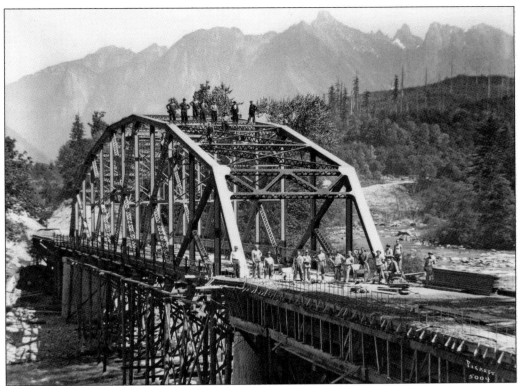

LOOKING NORTHWEST, THE NEW CASCADE SCENIC STEVENS PASS HIGHWAY BRIDGE NEAR INDEX. This bridge is now called the South Fork Bridge. After years of struggle, valley residents were rewarded with an upgraded road the length of the valley and over the pass.

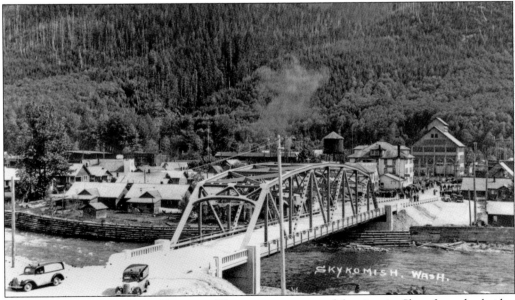

CONNECTING TO THE NEW HIGHWAY. There was a major celebration in Sky when the bridge opened in 1939, with police vans guarding the entrance and a good crowd gathered to see the bridge dedicated to town businessman Glick Henry.

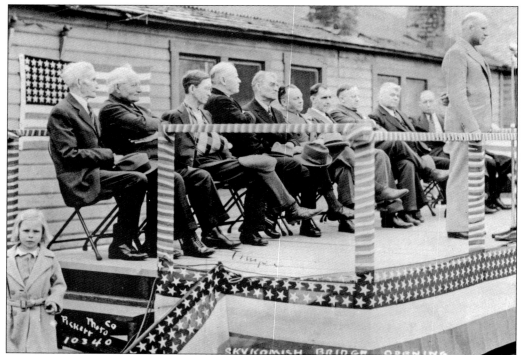

DEDICATION CEREMONY. Having cleared the land and built the town, one wonders what 83-year-old John Maloney (left) thought as he listened to various dignitaries. That highway, and the ease and greater selection of shopping "down below," ultimately closed Maloney's Store and Henry's Drugs. Next to Maloney is Pastor Forrest Brown, then Mayor William Timpe; sixth from left is George Leu Sr., and eighth from left is Mervin McDougal of Mac's Cash Store.

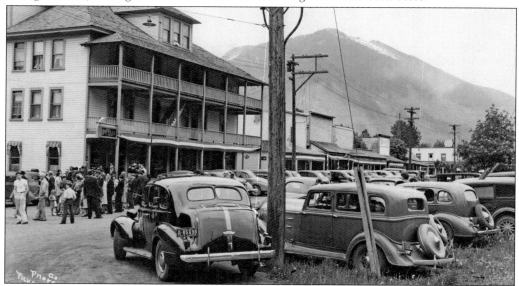

A POPULAR MYTH. Revisionists are fond of saying that the Great Depression lasted until World War II, but if the shiny new Pontiac Silver Streak at the dedication is any indication, by 1939, much of Skykomish Valley had recovered. Of the 20-plus cars in this picture, all but two or three are mid-1930s or newer.

Six

1940–1960

World War II dominated life in the valley as it did elsewhere during the first half of the 1940s. The timber industry stayed strong as wood products became part of the war effort, and dozens of women found work at the Bloedel-Donovan mill and with other industries that were largely "men only" until that time. All 18-year-olds were drafted. Those still in school received a guaranteed three high school credits to allow them to graduate in absentia. An ugly side of the patriotic fervor of the day was the incarceration of all Japanese Americans, citizens or not. The tiny Japanese American community in the Skykomish area was well integrated, and their children were class officers at school and key members of sports teams, but the loyalty of all persons of Japanese descent was officially in question in 1942, and they were rounded up and forced to sell out their homes and possessions at pennies on the dollar and be hauled away to relocation camps for the duration of the war.

Mining, too, was a casualty of the war in some cases. The Cleopatra Mine had produced more than $250,000 in ore by 1940, and a new tram to Miller River had just been built, but the mine was abandoned as nonessential to the wartime effort.

After the war, thousands of young men attended college on the GI Bill and changed the face of America. In the valley, businesses sprang up along Highway 2 in hopes the traveling public would stop and enjoy and spend time and money. But the improved road had its downside as well. As it became practical for logs to be moved by road, the mill in Milltown was sold and downsized, and it was finally closed forever in the late 1950s.

As automobile travel continued to increase, travel by train ended in the valley as well. "The Dinky" ceased running in 1958. Also new fans and diesel/electric technology allowed the Great Northern Railway to move trains safely through the 8-mile tunnel without switching to electric power in Skykomish and Wenatchee, and the railroad's role as a major employer in the upper valley continued to erode.

WORLD WAR II, EVERYBODY'S WAR. As an 18-year-old, Don Gallagher of Milltown was drafted out of high school. Seniors were given three "government" credits and graduated in absentia. At left, he is with his mother, Mary Rhodes Gallagher, and patriotic little brother David before shipping off to the Pacific. On that massive ocean, he ran into classmate Bobby Rickey (of Miller River) on Guam, and schoolmate Jack Haydock (of Skykomish) on the deck of another ship during refueling. They shouted to each other then sailed apart. Pictured below is Louie Lucky in his Skykomish class of 1945 senior picture. It was everybody's war.

A Skykomish Schoolgirl Reminisces

"The most amazing thing," says Yuriko Kawaguchi [S]uzuki about being relocated from Tule Lake Intern[m]ent Camp in California to the camp at Heart Moun[t]ain, Wyoming in 1943, **"was that the train went through [S]kykomish.** It had to stop to switch from coal to electric to [g]o through the tunnel, and we were all excited.

"When we learned it would be at least a 15 minute stop, [w]e pleaded with our Army escort to let us get out of the [tr]ain. He said OK, but only if we promised to stay together. [O]f course we promised, and of course as soon as our feet [h]it the ground we exploded in all directions. My sister and [I] ran to Maloney's store, where Lon Hildreth was working. [H]e seemed so happy to see us and to know we were OK.'

As Yuri talks about her life and the unattractive aspects [o]f her war experience she is clear. "I know some people [s]eem bitter or angry about what happened, but I never was. [I]t happened, but it never really made me feel this wasn't my [h]ome or that I didn't belong here."

In the '30's the Japanese community in Skykomish was [p]erhaps as well integrated as any non-white group could [h]ave been in America in that era. At school they were part [o]f everything as class and student body officers, playing [s]ports, and being involved in the same activities as everyone [e]lse. Yuriko grew up aware there were differences between [t]he Japanese community and the rest of the Milltown and [S]ky citizenry, and while it was important about who she [w]as, it merely was a difference, not a liability.

Yuriko was 13 and feeling like a normal American teen[a]ger when what turned out to be WWII paranoia, but at the [t]ime was perceived as real threat to national security, forced [a]ll persons of Japanese descent, whether they were citizens [o]r not, to be relocated into internment camps. Kawaguchis [w]ere picked up at their home in Milltown and driven by [p]addy wagon to Everett. She'll never forget it, she says.

"My brother was in the back and I was in the front seat, [b]ut then he got car sick, so I had to do the rest of the trip in the back and he got to ride in front." After that it was on to Tul[e] Lake Camp by train. She did her freshman year there.

"It wasn't much of a school," she says with her infectiou[s] laugh, "in fact it wasn't a school at all, just barracks." She spent her sophomore and junior years in school at Hart Mou[n]tain Camp. By her senior year it had become clear her community posed no threat to the nation, but because there was still war in the Pacific, her people were not allowed to retur[n] to the west coast so she joined her older sister in Minnesot[a] for her final year of high school.

Her father Kunitaro (Johnny) Kawaguchi had come to t[he] States as an 18-yr-old about the turn of the century and by t[he] early '20's had saved enough money to return to Japan to se[e] a bride. Yuriko doesn't know if her father chose and courte[d] her mother, if her father's family picked her mother, or if there was a third process involved, but in any case like man[y] of his peers in that era, he returned to the US with his bride, ultimately raising his family in Milltown and working at the mill until the war changed everything.

"I didn't even know the correct pronunciation of our name," she says with a laugh. "When we got to the camp I was told it was ka-wa-GOO-chi. We'd always called ourselves ka-WAH-gu-chi, because that's the way everyone in Sky pronounced it.

Although none of her family, nor any of the other Japanese-American families returned to live in Sky after the wa[r] she expresses only fond memories of Skykomish and often comes to the Old Timers' Picnic with her husband Jim Suzu[ki] one of the many decorated Japanese-American war veteran[s] who fought in Europe. They now live half the year near Sh[el]ton and the other half near Rancho Mirage, CA.

HAULED AWAY. While World War II changed nearly everyone's life in the valley, for the Japanese American community, the disruption was profound and, for many, degrading. Yuriko Kawaguchi was 13 when her family was relocated. Her older sister Shizuko and Kimiko Mitsui were the last Japanese Americans to graduate from Sky in 1942. Kimiko's brother Sammy, an underclassman and basketball star, was a decorated war hero for his service in Europe. In 2008, he was presented a diploma from Skykomish High School. (Courtesy of Skykomish Historical Society newsletter, *Rings of Time*.)

MABEL THE POND LILY. The nation may have had Rosie the Riveter, but Skykomish had Mabel Cleveland and another dozen women working at the mill while the men were off to war. High school girls working summers also did "men's" jobs at the mill.

HIGH VOLUME OF MOVEMENT. The war was a boon to the railroad; troop trains and supply trains traveled in all directions, moving people for training and deployment, as well as moving goods for the war effort.

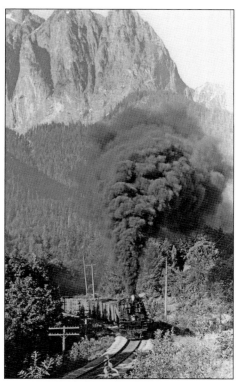

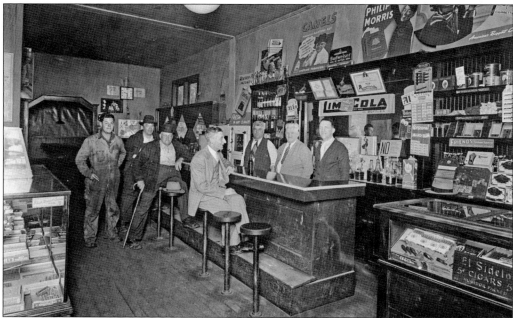

A GATHERING PLACE. The war also meant full employment and caused people to pull together with a sense of purpose, even if it was just to gather at the Whistling Post Tavern. From left to right are Les Fowler, Nick Weidert, Carl Comanche, Ray Massey, unidentified, Paul Fournier, and owner Bryan Thompson. Bryan and his wife, Glenda, operated the Whistling Post from the end of Prohibition in 1932 until the late 1970s.

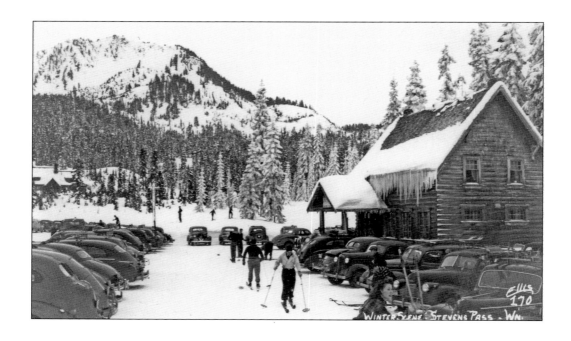

HITTING THE SLOPES. Throughout the war and into the 1950s, skiers flocked to Stevens Pass. As numbers increased, facilities improved to support their habits. T-bars and chairlifts replaced rope tows. Jack Nagel opened a ski shop and ski school. The long building at center left below is the state highway department garage.

THE SKIING NAGELS.
The Nagel skiers
included (from left
to right) Jack, Donna
Jean (Allen), Cathy,
and Judy. A largely
self-taught skier,
Jack represented the
United States in the
1952 Olympic Games
in Oslo, Norway, and
both of his daughters
were Olympic skiers
in the 1970s. Jack
also starred on
powerful Pop Gunn–
coached Skykomish
basketballs team that
beat Bothell and
other "A" schools
in the early 1940s.
He and Donna
Jean operated
a ski shop and
school at Stevens
Pass until 1962.

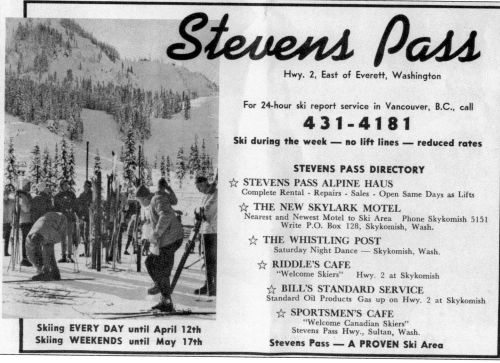

Stevens Pass

Hwy. 2, East of Everett, Washington

For 24-hour ski report service in Vancouver, B.C., call

431-4181

Ski during the week — no lift lines — reduced rates

STEVENS PASS DIRECTORY

☆ **STEVENS PASS ALPINE HAUS**
Complete Rental - Repairs - Sales - Open Same Days as Lifts

☆ **THE NEW SKYLARK MOTEL**
Nearest and Newest Motel to Ski Area Phone Skykomish 5151
Write P.O. Box 128, Skykomish, Wash.

☆ **THE WHISTLING POST**
Saturday Night Dance — Skykomish, Wash.

☆ **RIDDLE'S CAFE**
"Welcome Skiers" Hwy. 2 at Skykomish

☆ **BILL'S STANDARD SERVICE**
Standard Oil Products Gas up on Hwy. 2 at Skykomish

☆ **SPORTSMEN'S CAFE**
"Welcome Canadian Skiers"
Stevens Pass Hwy., Sultan, Wash.

Skiing EVERY DAY until April 12th
Skiing WEEKENDS until May 17th

Stevens Pass — A PROVEN Ski Area

SKYKOMISH COMMUNITY CHURCH. Originally built as a residence in 1922, the building was remodeled into a church in 1926. It has operated continuously since then.

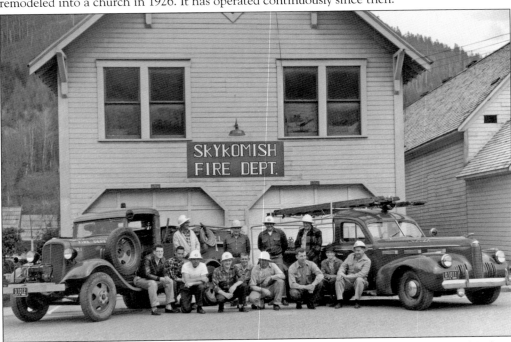

VOLUNTEER FIRE DEPARTMENT IN THE LATE 1950s. Shown are (first row) Bob Pasley, Bud Bishop, Ted Ryder, Chuck Hattenburg, Lowell Wedemeyer, Ham Hansen, Bob Crumpler, Jimmy Bishop, and Lloyd Austin; (second row) John Henry Jr., Sig Freestad, Bob Pownall, and Earl Riddle. The building behind them now houses the Skykomish Historical Society Museum, the town maintenance barn, and the King County Sheriff Deputy's office.

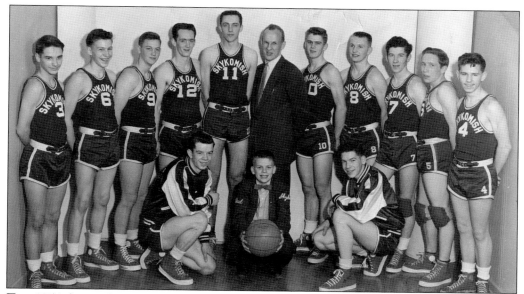

THE 1954 STATE CHAMPION SKYKOMISH ROCKETS. This was the smallest school to ever win the Class B championship. Shown are (first row) Donnie Flynn, manager Bud Richards, and Joe Sutton; (second row) Art Dahlgren, Dave Gallagher, Harold Haga, Elmer "Squeege" Dahl, Ronnie Beal, coach Dick Usitalo, Johnny Best, Buster Anderson, Bobby Wheeler, Gene "Tubby" Tubbs, and Doyle Matheny.

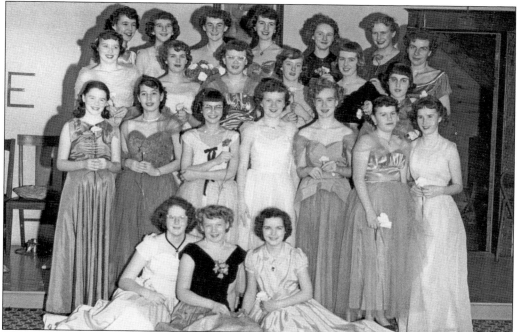

SKYKOMISH RAINBOW GIRLS, MID-1950s. Shown are (first row) Norma Dickison, Rita Cass, and Evelyn Beedle; (second row) Alma Loth, Mary Marquez, Vicky Hall, Carol Gamelin, Doretta Styles, Helen Loth, and Jerry Ann Kennedy; (third row) Reenie Hipp, Marlene Richards, Nancy Wagner, Joanie Dahl, Kaye McCleery, and Nancy Edgar; (fourth row) Marlene Simmons, Nola Best, Arlene Farnham, Rosalind Thompson, Judy Hattenburg, Janet Anderson, and ? Ashton.

BRIDAL FALLS LODGE AND MT PERSIS - STEVENS PASS HIGHWAY-WN

THE HIGHWAY GIVES, TAKES AWAY. The improved highway encouraged businesses to offer services to travelers, but as the road and cars improved even further, people drove farther without stopping to rest overnight. People could drive from Wenatchee to Seattle in less than four hours and did so. Establishments like the Bridal Falls Lodge and the Kitten Kat Motel flourished for a decade or two. The Mount Index Espresso stand is now at Bridal Falls. Alder and young fir trees replaced the Kitten Kat.

Kitten Kat Motel-Stevens Pass Hywy - Baring Wash - On the Beautiful Skykomish River - in the Cascade Mts.

UPPER VALLEY RELICS. The Alpine Falls "House of Souvenier" and El Cass-o-Rio Restaurant were operated into the 1950s. The restaurant burned and was never rebuilt, and the souvenier stand expired as well.

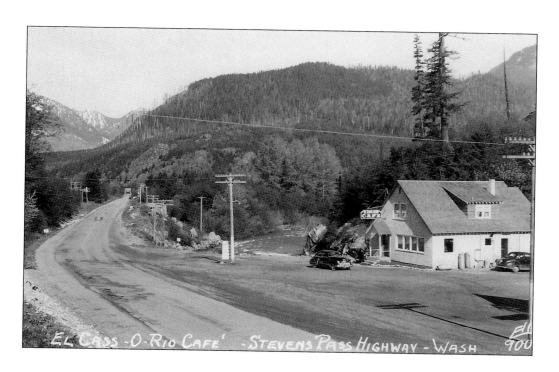

END OF AN ERA. Logging continued into the 1960s but did not employ numbers the way it had earlier. Timber was higher and smaller as a result. Steel towers replaced spar trees, and "grapple"-type loaders replaced both head loader and second loader positions on a logging crew. Holdridge and Wren Logging, shown here, were among the last of the local outfits to log consistently in the upper valley.

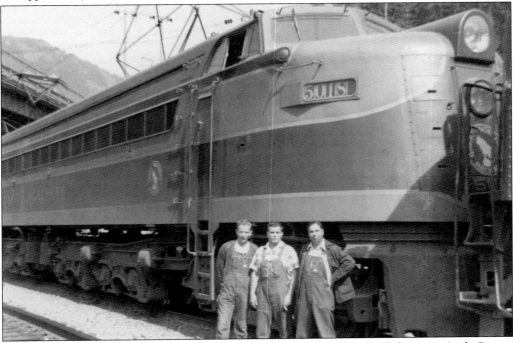

THE LAST ELECTRIC, JULY 31, 1956. From left to right are Ted Cleveland, fireman; Andy Strom, engineer; and Al Holevas, conductor. For 63 years, Skykomish played an important role in the operation of the Great Northern Railway. When new technology allowed GN to replace electrics with diesel engines through the Cascade Tunnel, the role of Skykomish as an important railroad town ended.

Seven

1960 TO THE FUTURE

The big money days in Skykomish Valley ended with the closing of the mines, the mills, and the cement plant and when the railroad no longer requiring a significant local labor force to make the trains run. There will again be modest logging when second-growth timber reaches harvestable age and perhaps mining again if some genius learns how to separate gold from arsenic in a way that does not pollute, or if the price of copper and the technology of extraction combine to make it profitable. But there will never again be hundreds of people supporting families doing the kind of labor done in the past. There will never again be that lone fire lookout living all summer on a mountaintop for barely minimum wage to watch for fires.

Those days are history.

Skiing and snowboarding remain popular, but climate fluctuation has meant hit-and-miss years at Stevens Pass of late. The mountains, the lakes, the beauty, the nature all still call out to be enjoyed even if fewer rivers and lakes are stocked with fish now.

Some members of the Skykomish Historical Society enjoy saying the past is the best future the valley has. Travelers stop to see and enjoy accounts of the amazing things that transpired here, and the historical society entertains dreams of being "the" Great Northern Railroad museum west of the Cascade Crest. The Iron Goat Trail is a popular, interesting opportunity for hikers, history buffs, and railroad fans.

The relationship between Skykomish and the railroad, now Burlington Northern Santa Fe, is not over. During decades of fueling and switching in Sky, massive amounts of oil were spilled. The railroad is in the process of a multi-million-dollar oil-spill cleanup where whole blocks of Skykomish are being moved, the ground underneath cleaned, then put back. Part of this construction is a new waste water treatment system, which will allow new buildings and perhaps new businesses to start up in town.

Talk continues of major improvements to U.S. Highway 2. People wishing to live a bucolic life and commute long distances to work continue to move farther up the valley.

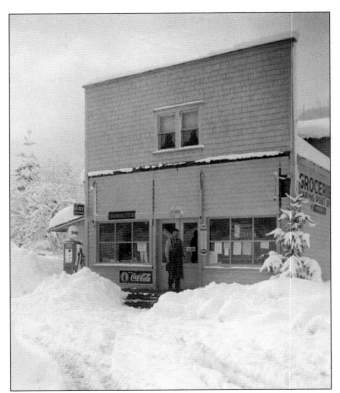

BARING STORE AND POST OFFICE. This was the only business between Index and Skykomish to remain in operation continuously throughout the decades. Built in the late 1800s, the post office was originally on the north side of the tracks, but it moved to its present location on the highway some decades later.

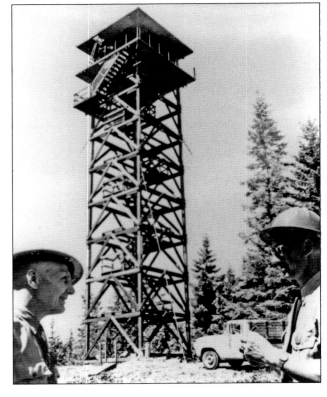

HEYBROOK LOOKOUT, 1964. Assistant district ranger Norm McCausland (left) and district ranger Dale Farley inspect the newly completed 67-foot tower. As with all other lookout stations, Heybrook went out of service in the 1970s as a result of air surveillance and satellite imaging. In 2001, Heybrook became available for hikers to rent for overnight stays.

SKYKOMISH HISTORICAL SOCIETY PROMOTER BOB NORTON AND MOKIE. For many years, Bob was the U.S. Forest Service "trail man" designing, building, and maintaining trails. He selected routing for portions of the Pacific Crest Trail (PCT) and named the Iron Goat Trail (IGT). Later he was a PCT "Trail Angel," assisting hikers resupplying in Skykomish during their Mexico-to-Canada trek. His collection, left to the Skykomish Historical Society, formed one of the backbones of this book.

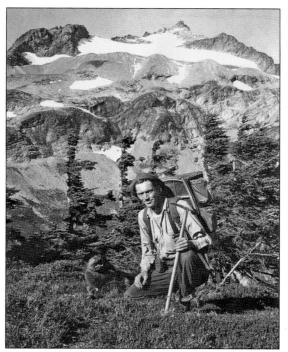

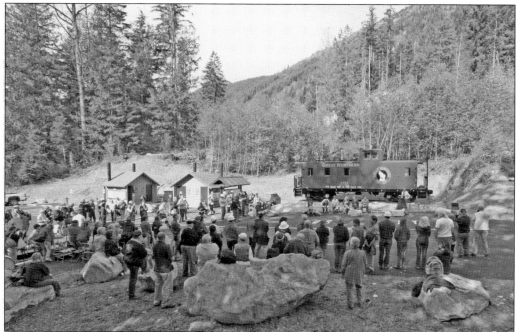

IRON GOAT TRAIL "SCENIC" DEDICATION CEREMONY IN 2002. The IGT offers 8 miles of outdoor, wheelchair-accessible experience for everyone between Scenic and Wellington, built by Volunteers for Outdoor Washington. People from all over come to work and enjoy the outdoors. Above, Washington Department of Transportation secretary Doug McDonald honors Ruth Ittner for her leadership in making the trail a reality. The trail follows the disused rail bed of the Great Northern line.

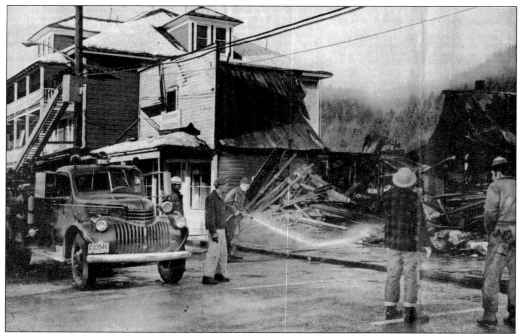

A Town in Peril. In December 1970, a fire gutted the block between Skykomish Hotel and the Whistling Post Tavern. An explosion in Lu's Market quickly engulfed it and spread to adjacent buildings. Quick work by Skykomish Volunteer Fire Department and Sultan Fire Department contained the fire to the three buildings, saving the hotel and tavern. This ground is now a park. At right in the photograph are Dennis McCausland, in hard hat, and Dave Gallagher.

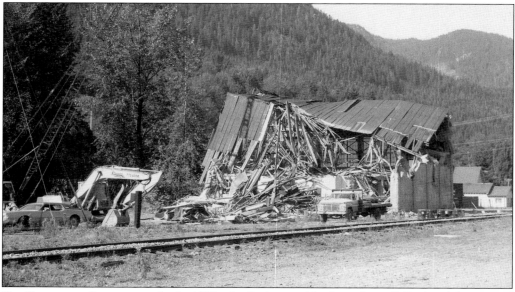

The End of the Substation. In the 1990s, the Burlington Northern Santa Fe Railroad determined that the substation was a hazard and had it demolished. The Vision for Skykomish project, completed in 2005 as part of the oil-cleanup preparation, places the depot, which is now on blocks as the soil under it is being cleaned, back on the south side of the tracks, where it was until 1922 on ground where the substation stood. Whether this vision will be fulfilled remains uncertain.

A NEW POST OFFICE. In 1968, a new, purpose-built post office opened in Skykomish, moving from the wing of Maloney's Store, where it had been for 60 years. In addition to providing service for locals, it also handles mailed "re-supply" for Pacific Crest Trial hikers, who come off the trail to connect with their goods.

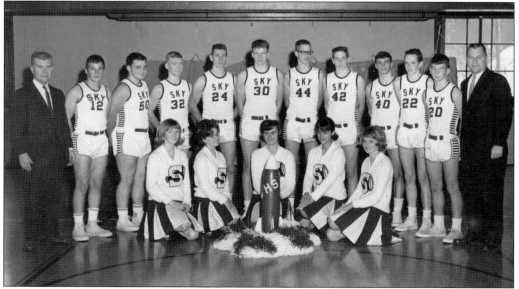

HIGH SCORERS. The 1965 Skykomish Rockets won 24 consecutive games, finishing sixth at the state "B" Basketball Tournament in Spokane. A balanced, excellent shooting group, they averaged 72 points per game, with all starters averaging well into double figures. Shown are (kneeling) Teddy Jo Ryder, Darlene Williams, Marilyn Golick, Sherry Haydock, and Frances Denman; (standing) assistant coach Charles Murrell, Pat Carlson, Mike Pownall, Steve Ryder, Steve Gibson, Bill Richards, Earl Valentine, Rick Ruchty, Bill Henry, Charlie Brown, Harold Cook, and coach Dennis Espland.

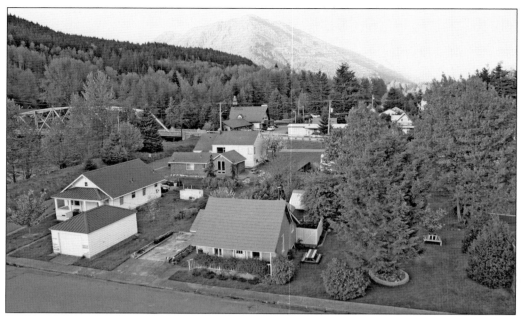

OIL-SPILL CLEANUP. When John Maloney wrestled that first old-growth fir to the ground, he could not have imagined what would follow. For more than a century, people hacked, hewed, and shaped the valley as they saw fit, but in the end, nature has reclaimed much of it. Even places where people still live, their footprint is changing. For more than six decades, massive amounts of oil were spilled by the railroad into the soil under Skykomish and into the river. This has demanded a cleanup, the proportions of which are stunning. The four photographs on these pages are taken from the roof of the school in Sky in June, September, and November 2006, and the final one in October 2007. (Both, courtesy of Michael Moore.)

A LONG PROJECT. These four photographs represent one phase of a six-year project to ameliorate the oil under the town. Each year, a different section of Sky is lifted, moved, cleaned under, and put back. The cleanup is being funded by the Burlington Northern Santa Fe Railroad and supervised by the Washington State Department of Ecology. Completion is years away and remains a moving target as additional testing continues to change the scope of the project. (Both, courtesy of Michael Moore.)

CASCADIA INN. Hatley's Hotel became the Cascadia about 1930 and has housed and fed clients almost continually since. Owner Henry Sladek has been able to keep the doors open throughout the oil cleanup so far, even when the route to reach the establishment has been challenging. Further tests will determine when and how much ground under it will be cleaned.

THE WHISTLING POST SALOON. The Whistling Post began life as the Olympia Tavern in 1897, and it remained in continuous operation even during Prohibition, when it was the Maple Leaf Confectionery, until 2008, when the oil cleanup forced its closure for some months. Owner Teddy Jo Ryder Brown and husband Charlie Brown are only the fourth owners in all that time and are pleased that the Whistling Post was back in place and able to reopen in November 2008.